Merry Christmas, M—

Love, Susan, Max & Joshua

Merry Christmas, M—

Love, Susan, Max & Joshua

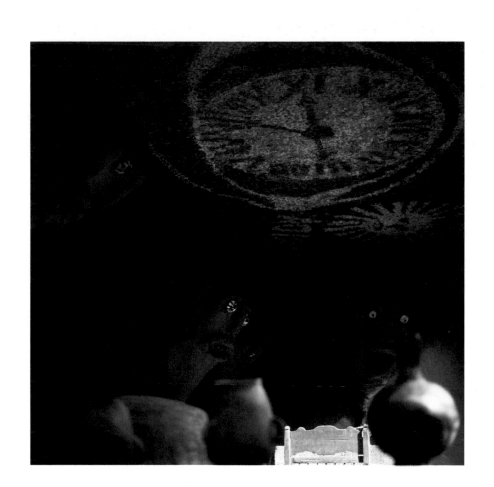

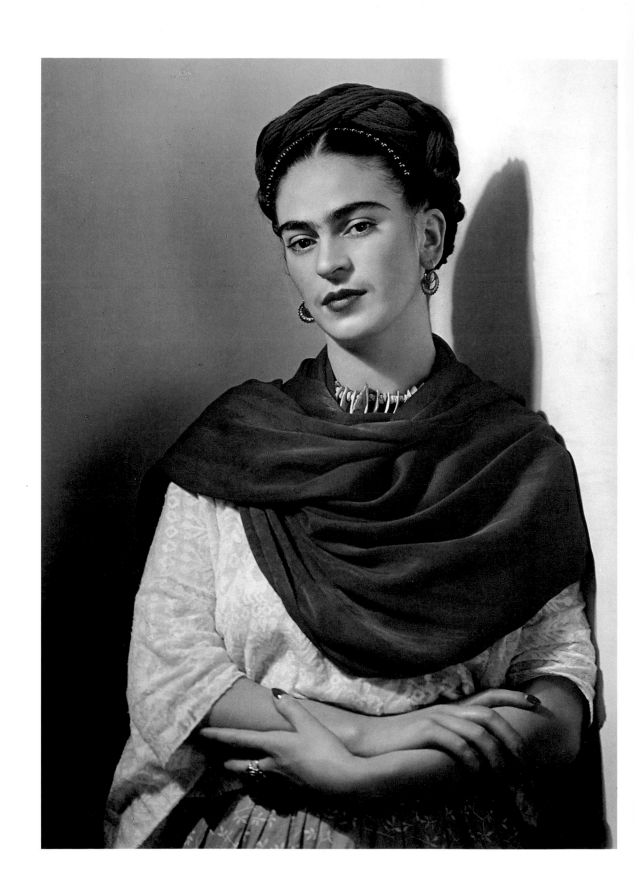

FRIDA KAHLO

THE BRUSH OF ANGUISH

Martha Zamora

Abridged and Translated by

MARILYN SODE SMITH

Chronicle Books

San Francisco

Edited, designed, and produced for Chronicle Books
by Marquand Books, Inc., Seattle

Works by Frida Kahlo are reproduced with the permission of the Instituto
National de Bellas Artes, Mexico City. Particular acknowledgment is due
to Mary-Anne Martin and Don Goodall for their assistance in securing
additional permissions.

Page 1: Untitled photograph from the series *Frida's Blue House*,
1987, by Debra Bloomfield

Typeset by The Type Gallery, Inc., Seattle
Printed and bound in Japan by Dai Nippon Printing Co., Ltd.

*To you, boys
To our moon, to our sun.* — M.Z.

Library of Congress Cataloging-in-Publication Data
Zamora, Martha, 1940–
[Frida. English]
Frida Kahlo : the brush of anguish / Martha Zamora;
abridged and translated by Marilyn Sode Smith.
p. cm.
Translation of: Frida: El Pincel de la Angustia
Includes bibliographical references.
ISBN 0-87701-746-8
1. Kahlo, Frida. 2. Painters—Mexico—Biography.
I. Smith, Marilyn S. II. Title.
ND259.K33Z3613 1990
759.972—dc20 90-33874

Distributed in Canada by Raincoast Books
112 East 3rd Avenue, Vancouver, B.C. V5T1C8

1 3 5 7 9 10 8 6 4 2

Chronicle Books
275 Fifth Street
San Francisco, California 94103

Contents

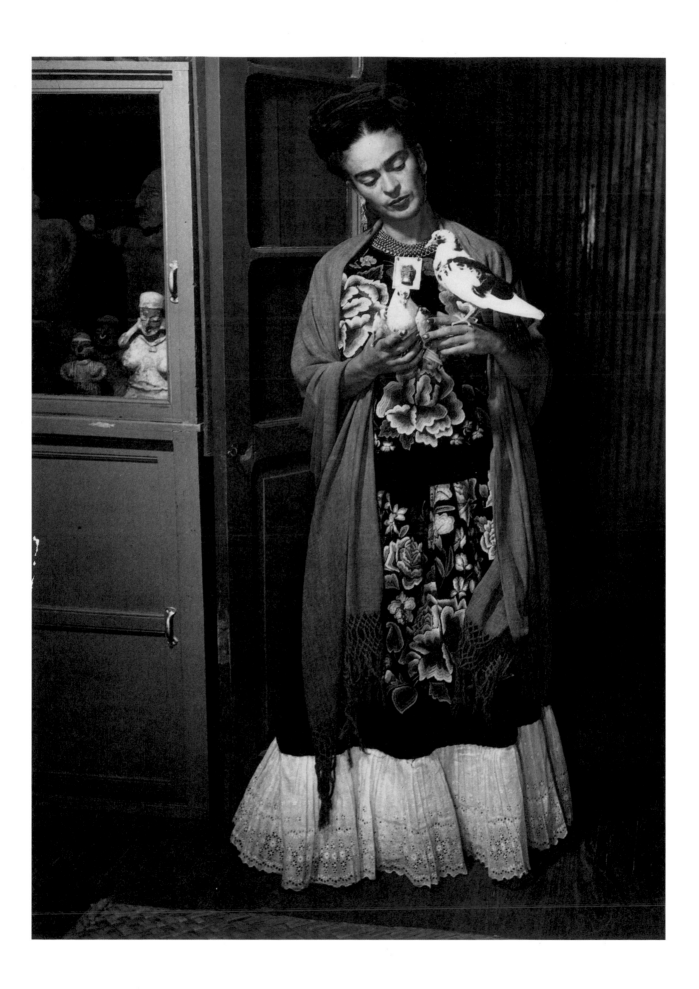

Preface

I began my research for the Spanish-language edition of this book twenty-seven years after Frida Kahlo's death, when the recollections of her contemporaries were already worn smooth by repetition and selected by memory. The soul's capricious reporter, memory filters out what hurts, combines the incidents that remain, and then adapts them to the form it wants to remember. Memory composes its own truth.

Imagination slips into the retelling; contradictory though loving statements combine with the luminosity of released memories. All of this is useful in composing a portrait of the multifaceted Frida. It is inevitable that I present her differently from the heroine we have been given in previous works.

We frequently sculpt our important personalities in marble, polishing them to excess until, frightened by their purity, we draw away from them. I prefer to show Frida with the fragility and imperfection of a human being, one whose talent has left us an exceptional and thrilling body of work. But I am aware that every individual is a mystery. Frida is still so near that the events I narrate involve many people who are living, and further confounding my investigations, each of them offers personal, often differing, interpretations of Kahlo's story.

Virginia Woolf said that a biography can be considered complete if it covers six or seven of the thousand personalities that a person might have. In my quest for the truth, I was even struggling against Frida herself, who seems to have wanted to invent her own biography, to plot her own myth and legend. To begin with, she invented a birth date and perhaps also a birthplace. She changed the names of her pictures, sending me in search of ones I had already located under other names. She recounted stories with so many changes drawn from her imagination that it complicated my discovery of the facts.

I began my work in total fascination before the perfect romantic heroine: one who suffered greatly, died young, and spoke directly through her art to our atavistic fears of sterility and death. Like many others, I am sure, I thought of her as a stoic woman who had suffered constantly in her life, as much from her problems of poor health as from the continual deception of a philandering husband. I believed Frida to be faithful and resigned, as she described herself in her writings. I viewed her as a marvelous artist who painted very little and lived a reclusive life, semi-invalid and continually sad, in her house in Coyoacán. What I found was very different from my preconceptions.

My profile turned out to be too simple and narrow to contain the vital force of Frida Kahlo. Frida's friends remember her as greatly enjoying life, happy, clever, and lively, always ready for fun. She had many and varied interests. She smoked too much and drank to excess. Bisexual during much of her life and a lesbian in her last years, Frida was unfaithful to her husband with the same frequency he evidently was to her. She traveled in Europe and the United States. She built for herself a personal world separate from that of her famous husband, and she produced many more paintings than I had at first imagined.

Frida was much more than an artist's model or the wife of a famous painter. With strength and patient dedication, she created her own work, distinct from the art movements of her time. She demonstrated that she could flourish beneath the shade of a tree as prominent as Diego.

All the physical and spiritual suffering Kahlo experienced is reflected in her art. Obsessed with her health and suffering, she created a pictorial oeuvre that is intense and emotive. It narrates with a desolate sensitivity what she wanted us to know of her life; her own

pictures give shape to the Frida Kahlo myth. A marvelous masochist, Frida united the natural anguish of her fate with an enormous propensity for self-destruction. Placing herself constantly in extreme situations, she tested her limits with a vital intensity. Her paintings reveal her interior world at the same time that they force an awareness of her loneliness and misery. Standing alone, they have a value that requires no biographical corroboration.

In this book I have not eliminated the anecdotal, because it brings us much closer to the warm human being, to the woman with sparks flashing from her mischievous eyes. The anecdotes give a clear picture of the Frida that many people remember: a woman who was as sweet and tender as she was brave, tough, or haughty. Interested in everything, delighted by dirty words and phrases, she had a malicious, intelligent sense of humor that brought smiles to her lips, smiles that never appear in her self-portraits.

Frida must have scattered an enormous amount of love in her lifetime, for now, more than thirty-five years after her death, her image is still with us. At times she seemed to support and even cause terrible misfortunes in order to fall headlong into heartbreaking circumstances. All the while, she observed with detached fascination.

I regret not being able to tell all the adventures of my search for Frida, a journey that took me from sumptuous mansions to humble environs, to hospitals, tombs, and museums, looking for her people and her paintings. I noticed how rarely historical events alone had left a mark on the memory of the people I interviewed. Instead, it was the emotional response to an experience that remained deeply engraved in their treasured remembrances.

Now, with the image of her paintings in my mind, I call up the excitement of my one childhood glimpse of Frida walking along Avenida Juárez, elegant and colorful. I offer her this book, which lovingly presents some of what I have learned.

Martha Zamora

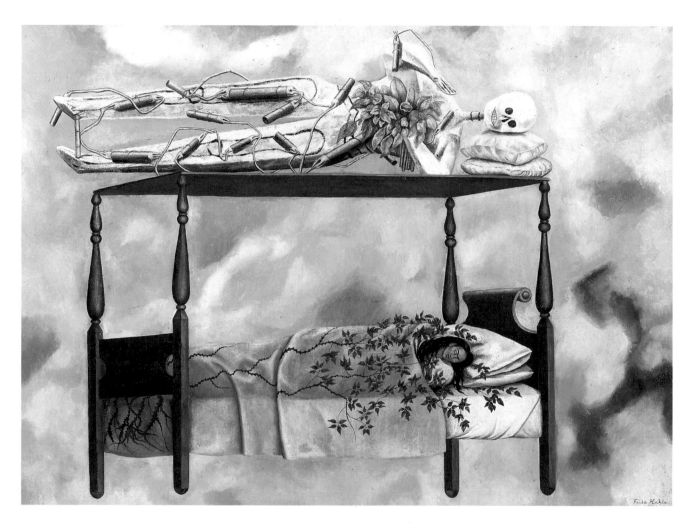

The Dream
1940

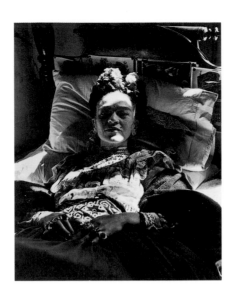

Murdered by Life

It was raining, one of those July days in Mexico when torrents fall. Frida had always liked the rain; it bathed and freshened her garden in Coyoacán and washed away the dust from the paving stones of the street. And rain kept reality out of focus, blurring life's edges. It helped the sad outline of her present life.

A while ago she had asked to have her bed moved from the bedroom to the small entry hall that opened onto her studio. From there, through the doorway, she could see out to the garden, the stairway, the reflecting pool. In this section of the house, designed and built by her husband, Diego Rivera, the walls were made of volcanic stone from nearby Pedregal de San Angel. To her old family home, the Casa Azul, he had added a new studio for her, well-lighted and spacious; the entry hall where she was now; a bedroom; and downstairs, a small dining room. Clay pots embedded in the outside wall served as nests for the doves, and the exterior ceilings were adorned with designs by Diego in natural-colored stones.

Frida was burning with fever, weak and restless, as she had been almost constantly for the last few weeks. From her bed, she could hear the conversation of someone in the dining room below. Dr. Guillermo de Velasco y Polo had arrived.

"After examining her," Dr. Velasco y Polo has recounted, "I went down to the dining room and said to Diego, 'Frida's condition is very bad, she is feverish.' He nodded in agreement, but said nothing. I left, planning to return the next day."

Frida was being cared for by a practical nurse, Cornelia Mayet. "Two days before, Ruth Rivera came to visit accompanied by her friend, I think he was a bullfighter," related Mayet. "Suddenly, Frida let out a scream and told us she had a terrible pain, that she felt as though they were cutting off her leg again. I was just on the point of leaving because it was Sunday, but I stayed for the crisis. We called the doctors, and they told me to give her the medicines we had to make her sleep. When she quieted down and the other nurses had arrived, I left. She slept almost without interruption for two days on the doctors' instructions.

"The afternoon before she died, she woke up and was very lucid, very rested. She wanted to see Dieguito, she told me, because she had something to tell him. She was thankful I was there, that I had not abandoned her, and she asked about her sister Cristina. I told the señor, who was downstairs eating with two other people, but he didn't come upstairs right away.

"When he came up to be with her, señora Frida began to give him advice about how he should do everything, but she warned him, 'If you want your life to be aimless as a kite, just blown about by the wind,' that's the way it would be. She told him that she was feeling very well now, that she was not in pain at all. Then the maestro told me that I could go and rest because I hadn't had any sleep for a long while, and that he would give her the pills she took for sleeping. Frida usually put a bunch in her mouth all at once. She was supposed to take only seven, so I told señor Diego that, and I counted the pills that were in the jar.

"As I left to sleep for a while in the adjoining bedroom, the señora was giving him a ring she had hidden away as a present for him next August, when they would have celebrated their twenty-fifth wedding anniversary.

"The next day, I counted the pills. Eleven were gone. About six o'clock in the morning, I heard the arrival of maestro Diego's assistant, Manuel. I left the bedroom and went toward Frida's bed. Her eyes were open, staring, and looking toward one side. Her right arm was hanging out of bed. I touched her and cried out. She was cold. I shouted for Manuel to come upstairs. Then he went to the studio to tell señor Rivera what had happened.

"We picked her up to move her from the bed, and she was still flexible, cold but soft. On her back, there were signs of internal bleeding, as if from a lot of little veins. The doctors said that it was a

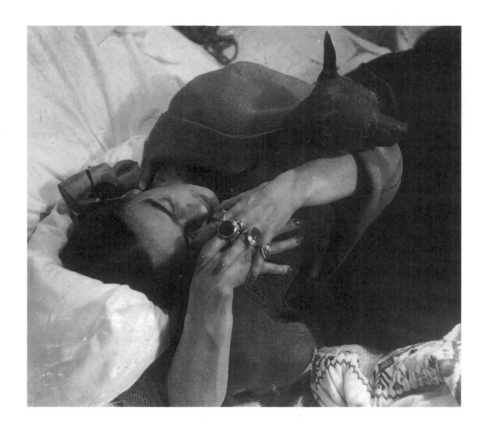

pulmonary effusion. There was no rigor mortis. I had laid out other people before, and after two hours it was impossible to even move their arms, but not with her. Ruth Rivera, Pita Amor, and Lola Alvarez Bravo helped me dress her and do her hair. I remember that Lupe Rivera, Aurora Reyes, and her sister Cristina were there, too."

Diego came from his studio in San Angel, where he most often slept and worked in the last few years. Everyone who saw him said that he grew old immediately, that he was aged by the tenderness he felt welling up inside on seeing his "Chiquita" dead. He locked himself up in the bedroom, refusing to see anyone, while great crowds of friends and relatives arrived at the house. Afterward, he told his assistant on the San Francisco murals, Emmy Lou Packard, "I had no idea I was going to miss her so much."

On July 13, 1954, the physical presence of Frida abandoned the Casa Azul in Coyoacán forever.

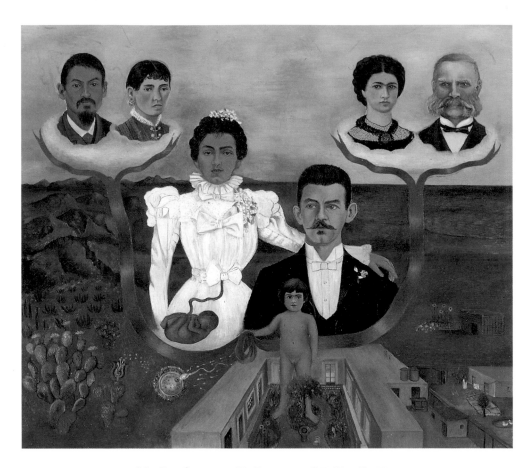

My Grandparents, My Parents, and I (Family Tree)
1936

Frida in Coyoacán
c. 1927

The Beginning

Rain in the morning in Coyoacán, for her birth as well as her death. Magdalena Carmen Frida Kahlo Calderón came into the world on the sixth of July, 1907, maybe in the family home, the Casa Azul, as she always claimed, maybe down the street at her grandmother's house, as shown in the official registry of her birth.

An hour by streetcar from Mexico City, Coyoacán was surrounded by flat, open land, cornfields, and ranches. Frida absorbed the history and habits of every corner of the village; she explored its river, markets, churches, and plazas. She knew when the street markets and neighborhood fairs would be held, which street vendors sold the best quesadillas, and where to buy the most amusing toys. She spent hours strolling the streets with her friends, talking to merchants and shoeshine boys, and roaming the verdant parks and gardens.

The Casa Azul, a rambling, blue structure in colonial style, was built by Guillermo Kahlo a few years before Frida's birth. Tall, shuttered windows opened to the street, and within, a series of interconnected rooms surrounded a large inner patio. Frida's part-Indian mother, Matilde Calderón, a rigidly conventional woman, was a meticulous housekeeper and a devout Catholic. She frequently took communion, went to confession, and said the rosary in the late afternoon with relatives and friends. She chose not to raise her husband's two daughters by a previous marriage, sending them off to

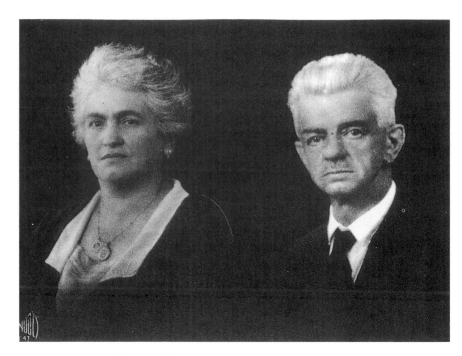

Matilde Calderón de Kahlo and Guillermo Kahlo, c. 1932

Cristina Kahlo, Isabel Campos, and
Frida, 1919

live in a convent orphanage. Her relationship with her own four
daughters was strained as well; the oldest two married and left home
at very young ages. By the time Frida was in her teens, her mother
was in poor health and struggling with the family's finances.
Although Matilde Calderón's letters prove otherwise, Frida once
said with irony that her mother couldn't read or write, but she
certainly could count money.

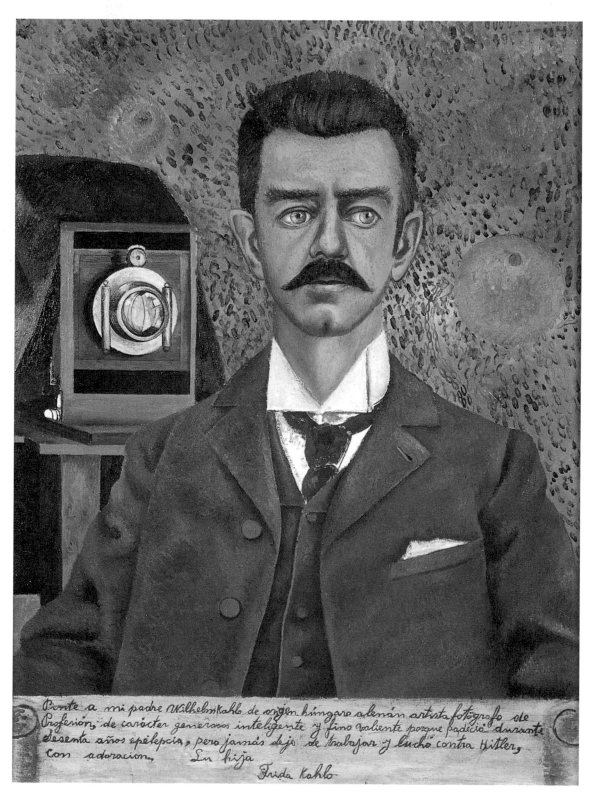

Portrait of My Father
1951

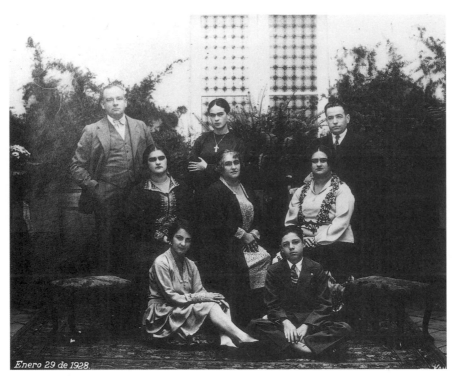

Enero 29 de 1928.

Frida wearing a crucifix, center back; her sisters Matilde and Adriana with their
spouses; her younger sister Cristina and a nephew; Matilde Calderón, center, 1928

Frida's father was a greater influence in her life. Shy,
taciturn, withdrawn, Wilhelm Kahlo was a German Jew of Hun-
garian descent who had come to Mexico as a young man. He
eventually found work in his father's trade, the jewelry business.
When his first wife died giving birth to their second daughter, he
turned for help to Matilde, a co-worker. They married three months
later. Guillermo, as he now called himself, took up his new father-
in-law's career of photography and soon had his own studio.

Guillermo's always tender attachment to his "Liebe Frida"
strengthened when she was stricken with polio at age six. Her right
leg became noticeably thinner than the left, and frequent exercise
was prescribed to speed her recuperation. Guillermo was the parent
to help her, encouraging her to swim, ride a bicycle, and participate
in sports. She often accompanied her father on outings with his
camera, assisting him with the equipment, and she worked in his
studio, learning to retouch, develop, and color his photographs.

Possibly because of her bout with polio, Frida entered
elementary school later than her peers. About this time she
developed two tendencies that would become lifelong habits: she
began to claim to be younger than she was, and to hide her physical
disfigurement. In childhood and later photographs, she always posed
with her right leg concealed.

In 1922 Frida was ready to enter high school. A bright student, she qualified to attend Mexico City's National Preparatory School, by far the best school in Mexico at the time, with a faculty of prominent intellectuals from many disciplines. Frida was going out into the world, and a very different world it was, for Mexico as well as young Frida.

The Mexican Revolution, which began three years after Frida's birth, had inspired a dynamic new sense of nationalism throughout the country. Turning away from dictator Porfirio Díaz and his elitist followers, and their love of all things European, Mexico looked proudly to its native roots and initiated a deliberate program of cultural reconstruction and educational development. The country's marvelous archaeological history, heretofore little known and under-valued, was being revealed in excavations of the ancient ruins at Mitla, Monte Alban, El Tajin, and Teotihuacán, and indigenous arts and crafts of all regions gained new attention.

Under the direction of the education minister, José Vascon-celos, literacy campaigns were initiated, women were integrated into the school system, and libraries and a state publishing house were set up to provide inexpensive books. Vasconcelos is also credited with stimulating the Mexican muralist movement. Believing that Mexican citizens would acquire a more profound awareness of their history by seeing it depicted on public walls, he turned over large areas of civic buildings to artists such as José Clemente Orozco, David Alfaro Siqueiros, and Diego Rivera, who soon became internationally famous as "Los Tres Grandes," the three greats, of the movement. One of the buildings whose courtyard walls they painted was the National Preparatory School, and there Diego and Frida met for the first time.

Women had only recently been admitted to the Prepa; Frida was one of only thirty-five females in a class of approximately two thousand. She soon established herself as a rebellious student full of pranks, audacity, and humor, with a lively imagination and an astounding mastery of foul language, which she picked up from conversations with bootblacks and street vendors in her neighbor-hood. Although actually older (at fifteen) and more mature than many of her schoolmates, she said she was three years younger, claiming 1910 as her birth year so she could declare herself a

Frida wearing a man's suit, far left, with members of her family, c. 1924

"daughter of the revolution." This fiction exemplifies her habit of calculated fabrication for dramatic effect.

Frida went to school dressed in a white middy blouse and a big tie, a navy blue pleated skirt, and a straw hat decorated with bows. Her sister Adriana fixed the bows for her, but under precise instructions from Frida, who claimed her sister "had no sense of line or harmony." Always conscious of her appearance and her effect on others, Frida was daring enough on occasion to wear a man's suit or dramatic dresses of her own design.

Her school notebooks were filled with sketches, including one of herself in her straw hat, her dark hair cut in straight bangs, her signature black eyebrows growing together across her forehead. But although she studied composition and drawing, art was merely an amusing pastime. Frida was more attracted to the intellectual pursuits of a student group known as the Cachuchas, so named for the crocheted red caps they wore. An informal gang of nine, the Cachuchas had strong political concerns as well as interests in

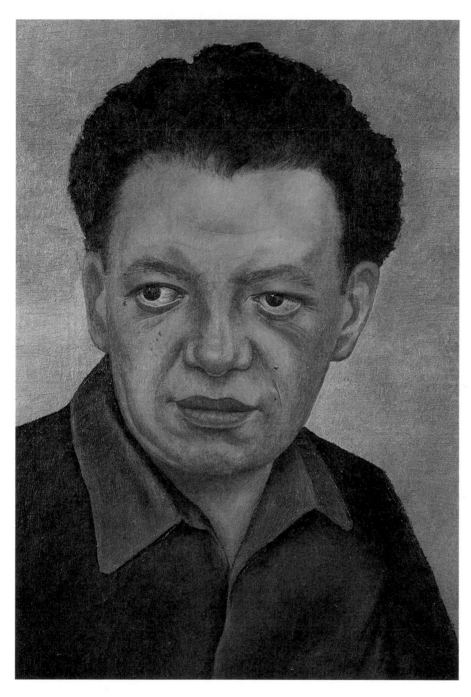

Portrait of Diego Rivera
1937

A page from Frida's school notebook,
c. 1922

poetry, art, literature, history, and philosophy; all read at least one foreign language. Frida called the young men her *carnales*, blood brothers, and the girls were like sisters, her *'manas*.

At about this time Frida announced to friends, "You don't know what I would give to have a child by Diego Rivera." Her fellow students were stupefied, for despite their admiration for his talent as a painter, they saw him as a fat, untidy, bulging-eyed married man. Rivera was then working on his frescoes at the school, and Frida subjected him to her tricks. Once she soaped the school steps, hoping to make him slip and fall; other times she teased his wife, Lupe Marín, about other women in Diego's life.

Frida fell in love, however, with the charismatic leader of the Cachuchas, Alejandro Gómez Arias, an intelligent, attractive, well-mannered young man of a good family. "We were very good friends all our lives; we were more than sweethearts but never had wedding plans or anything like that, because we were still very young," Gómez Arias has said. Frida's ardent correspondence with Alejandro reveals her maturation from a young girl into a woman. Years later she said, "For me, Alex ignited love, the ambition to know, to know it all."

Frida's precocious behavior worried her parents. Societal restraints on women were severe, and even the concept of coeducation was upsetting to the families of proper young ladies. But Frida

enjoyed flouting the rules, whether by a small transgression like wearing bobby socks, prohibited by the school dress code, or by a deviation as extreme as a sexual adventure with an older woman. This affair and other relationships not only scandalized her family but caused Frida to be ostracized by many of her schoolmates. Her passionate temperament had little respect for limitations, and Frida was not ashamed of her blossoming sexuality. She wrote to Gómez Arias: "I don't care. I like myself the way I am."

Guillermo Kahlo's business began to flounder while Frida was attending the Prepa, and as his financial situation worsened, he was forced to mortgage the Casa Azul. In order to help out, Frida enrolled in a business school in 1925 and learned to type. Her first jobs in a pharmacy and lumber yard office were unsuccessful, but eventually she was employed as an apprentice in an engraving studio.

That same year, on September 17, Frida and Alejandro spent the afternoon wandering among the colorful street stalls set up for Mexican National Day celebrations. On boarding a train to return to Coyoacán, Frida discovered that she had lost a little toy parasol Alejandro had just bought for her. They retraced their steps, and when it couldn't be found, they bought a *balero*, a cup-and-ball.

A bus happened by, a brightly painted new one with two long benches along the sides. Frida and Alejandro felt lucky to catch it. The driver, rushing to cross the busy city on the way out of town, boldly tried to pass in front of a turning streetcar. He didn't succeed: the heavy streetcar moved forward and collided with the bus, pushing relentlessly into its side and pressing against the benches where the passengers sat.

Gómez Arias still marvels at the elasticity of the vehicle, remembering that he felt his knees pressing against those of the person sitting across from him, just before the bus shattered to pieces. He regained consciousness underneath the streetcar, with the darkness of the metal chassis above him and a terrible fear that it would continue moving and mangle him. When he was able to sit up, he noticed that the front of his coat had somehow disappeared. He set out to find Frida.

At the moment of the accident, Frida was more concerned about the loss of her new toy, which had flown out of her hand, than she was with the seriousness of the collision. Alejandro found her bathed in blood, without her clothes, virtually impaled on the rod of a

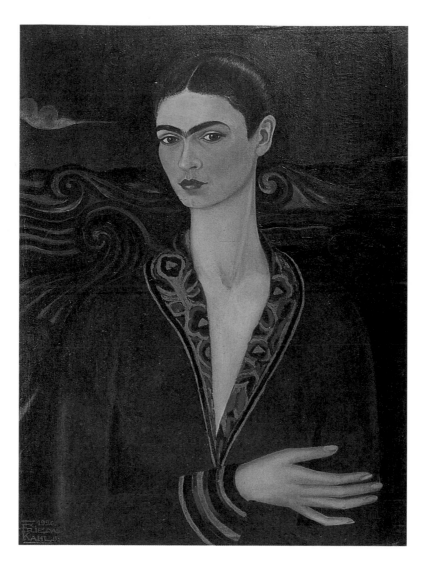

Self-Portrait Wearing a Velvet Dress
1926

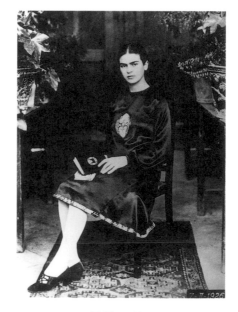

Frida, 1926

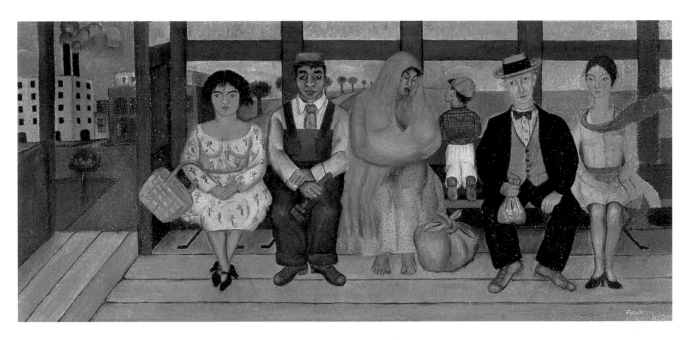

The Bus
1929

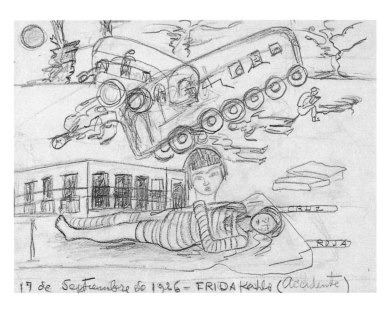

Accident
1926

metal handrail. A bag carried by a passenger had spilled gold powder all over, and Frida's bloodied body was sprinkled with it. Curious onlookers cried, "Help for the little ballerina!"

An overall-clad worker, whom Alejandro thought he recognized as an employee of the Prepa, looked at Frida and said, "That has to be taken out of her." With no more ado he pulled the metal rod out of Frida's body to the terrible sound of breaking bones. Alejandro, horrified, carried her to a pool hall across the street, put her on a table, and covered her with the shreds of his ruined coat. They waited for an ambulance as Frida screamed in pain.

The wounded victims were taken to a nearby Red Cross hospital and divided into two groups: those who would receive immediate medical attention and those who, because of their grave condition, were considered beyond help. Frida was placed in the second group, and only after the shaken Alejandro pleaded with doctors, begging them to help, did they attend her.

A description of the wounds Frida suffered in the accident was compiled by her doctor in a clinical history years later: "Fracture of the third and fourth lumbar vertebrae; pelvic fractures; fracture of the right foot; dislocation of the left elbow; deep abdominal wound produced by a metal rod entering through the left hip and exiting through the genitals. Acute peritonitis; cystitis with drainage for several days." In other versions Frida added injuries, such as fractures of a cervical vertebra and two ribs, eleven fractures in the right leg, and dislocation of the left shoulder.

Frida always maintained that the metal rod pierced her uterus and emerged through her vagina. "[That's when] I lost my virginity," she said. Gómez Arias says that "the wound was much higher up and hit the pelvic bone; the invention of the point of exit was to hide other things." She would also identify the accident as the cause of her inability to bear children, but it was only one of her many explanations for that condition.

Frida told Alejandro, "In this hospital, death dances around my bed at night." But Frida's youth and characteristic vitality pulled her through. She was able to return home after a month, although she was almost completely immobilized by splints protecting her various fractures. Friends from school visited her frequently at first, but the long distance to her home in Coyoacán eventually discouraged regular visits; she began to feel out of touch. Although her health might have allowed it, Frida never resumed her studies.

While confined to bed, Frida began to paint, using a small lap easel her mother had ordered for her. Overhead, in the canopy of her bed, she positioned a mirror so she could use her reflection as a subject, an arrangement signaling the beginning of her focus on self-portraits. As she recovered and was up and around more, Frida also intermittently painted larger pictures, posing friends, relatives, and children as well as herself.

During her hospitalization and the following two years, Frida constantly wrote to Alejandro. Addressed to "Alex de mi vida" or "Mi adorado Alex," the letters are full of her colorful slang, sprinklings of English and Italian words, drawings and caricatures, poignant mention of her thwarted plans—"I who so many times dreamed of being a traveler and navigator!... It is one of life's ironies"—and wry references to death: "At least the Bald One [skull] didn't get me."

Frida suffered grim periods of relapse, questionable medical treatments, a long series of confining plaster and metal corsets, and numerous operations. The backwardness of medical technology at that time in Mexico resulted in some grotesque therapy.

She wrote to Alejandro, "This Friday they put me in a plaster cast and since then it has been a real martyrdom; there is nothing to compare it with. I feel like I am suffocating, with a terrible pain in my lungs and in all my back; I can't even touch my leg, and I can hardly walk, much less sleep. Imagine: they had me hanging, just from my head, for two and a half hours, and afterwards I was propped up on my toes for another hour, while the cast was being dried with hot air. But, even so, when I got home it was still damp.... I'll have this martyrdom for three or four months and if this doesn't make me well, I sincerely want to die, because I can't take it any more. It's not only the physical suffering but also that I don't have the least distraction, I don't get out of this room, I can't do anything, I can't walk, I'm completely without hope now, and above all you're not here."

Fighting to recover physically, Frida was also struggling to keep Alejandro. But he was back at school, busy with other activities and interests; furthermore, he was being sent to Europe on a pleasure and study trip that would keep him away from Frida from March until November of 1927. Her letters continued, detailing each advance or regression of her mental and physical health.

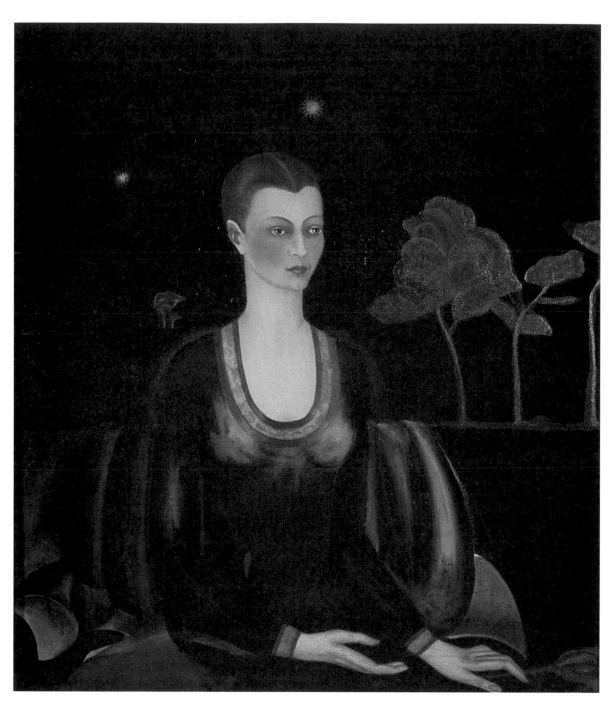

Portrait of Alicia Galant
1927

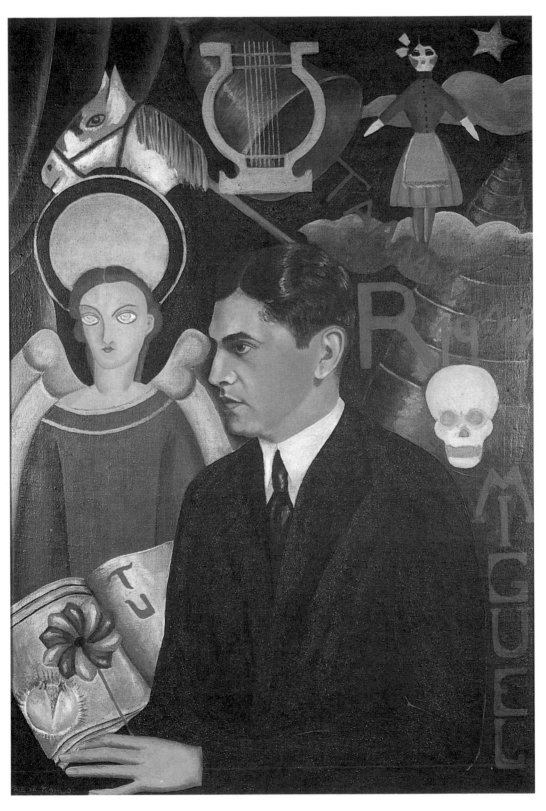

Portrait of Miguel N. Lira
1927

Alejandro Gómez Arias, c. 1924

In June 1927 she wrote, "Monday, they're going to change my cast for the third time, this time to keep me immobilized without being able to walk for two or three months, until my spine knits together perfectly, and I don't know if afterwards they'll have to operate on me.... Every day I'm skinnier, and when you come back, you're really going to be in for a shock when you see how horrible I am with this dreadful apparatus. Afterward, I'm going to be a thousand times worse, so you can just imagine: after having been lying down for a month (the way you left me) and another month with two different devices, and now another two months flat on my back put in a coating of plaster, then six months again with the lighter apparatus so I can walk.... Is that enough to drive a person crazy, or not?"

On September 9, 1927, she noted, "On the seventeenth it will be two years since our tragedy. For sure I certainly will remember it terribly well, although it's stupid, isn't it? I haven't painted anything new (and won't), until you come back.... I've suffered terribly, and I'm almost neurotic, and I've let myself become such an ignoramus, I'm totally demoralized." And eight days later: "I'm still very sick and almost without any hope. As always, nobody believes it. To-day is the seventeenth of September, the worst day of all because I'm alone."

Among the vague diagnoses and suggested treatments mentioned in Frida's letters were thermocauterization, an operation to graft a piece of bone from her leg, the discovery of a lesion on her sciatic nerve, and constant changes of immobilizing corsets in different materials. Undoubtedly her recovery and moods were affected by the household gloom dictated by her parents' poor health and the family's precarious economic situation. The Casa Azul was still mortgaged, and at one point all the fine furnishings had to be auctioned off. Her mother's daily bad humor coupled with her father's misanthropic behavior caused her to describe her home as "one of the saddest I have ever seen."

A Prepa friend who remained close to Frida during her recuperation was Germán de Campo. A man of ardent political convictions, he was a major influence on the ideologically leftist road she took then and maintained all her life. De Campo introduced Frida to the weekly salons of painters, writers, photographers, and intellectuals held by Tina Modotti, the strikingly beautiful Italian who had come to Mexico from the United States with photographer Edward Weston. Modotti, an outstanding photographer herself and Weston's protégé, worked for the muralists and was not only a model for Diego Rivera but probably the reason he separated at that time from his wife, Lupe Marín.

Frida admired Modotti above all for her political militancy and the practical way she applied the strength of her convictions to her daily actions. Modotti apparently sponsored Frida's entry into the Communist party. Her hair now cut very short and styled close to her head, Frida no longer wore the white blouse of her student days, but was more apt to be seen in the distinctive red shirt of the party. (A Rivera mural, *Distributing Arms*, in Mexico City's Ministry of Public Education, portrays both Modotti and a red-shirt-clad Frida.)

One account suggests that Frida renewed her acquaintance with Diego Rivera at a Modotti soiree where he impressed her with a show of flamboyant behavior, using a pistol to shoot a phonograph. Frida told another story in an interview with the Mexican journalist Bambi:

"I took four little pictures to Diego who was painting up on the scaffolds at the Ministry of Public Education. Without hesitating a moment I said to him, 'Diego, come down,' and so, since he is so humble, so agreeable, he came down. 'Look, I didn't come to flirt

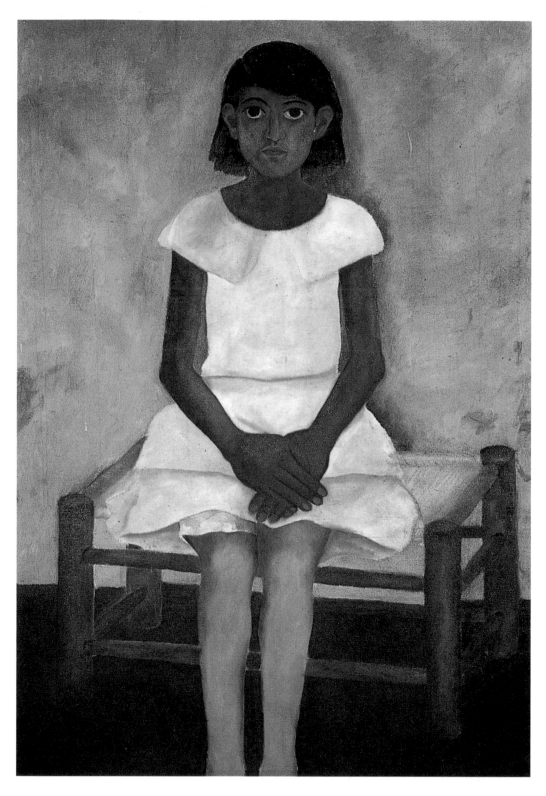

Portrait of a Girl
1929

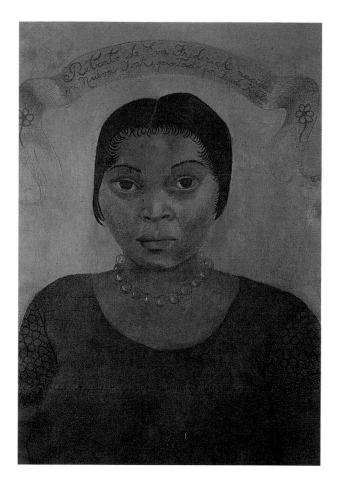

Portrait of Eva Frederick
1931

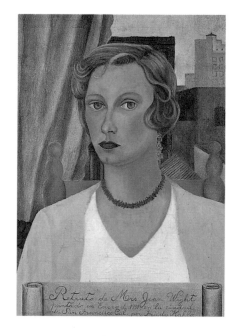

Portrait of Mrs. Jean Wight
1931

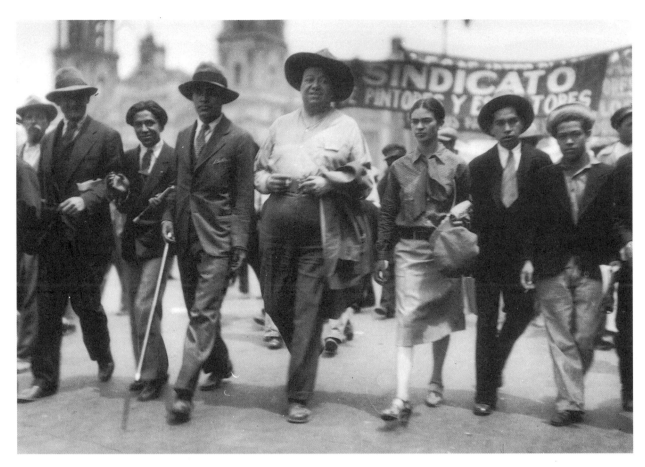

Frida and Diego at a demonstration of the Syndicate of Technical Workers, Painters, and Sculptors, 1929

with you or anything, even though you are a womanizer, I came to show you my painting. If it interests you, tell me so, if it doesn't interest you, tell me that too, so I can get to work on something else to help out my parents.' He told me, 'Look, I'm very much interested in your painting, especially this self-portrait which is the most original. The other three seem to me to be influenced by what you've seen. Go on home, paint a picture, and next Sunday, I'll come to see it and tell you.' So I did, and he said, 'You have talent.'"

Diego told biographer Gladys March a similar story, adding that when he learned that the young woman who had sought his opinion of her paintings was Frida Kahlo, he immediately remembered the little girl who long ago had taunted his wife Lupe Marín in the halls of the Prepa and had been such a troublesome youngster to the school authorities.

True to his word, Rivera came to call on that Sunday, and many others. Frida became "the most important thing in my life," he said, and on August 21, 1929, they were married in the historic town hall of Coyoacán.

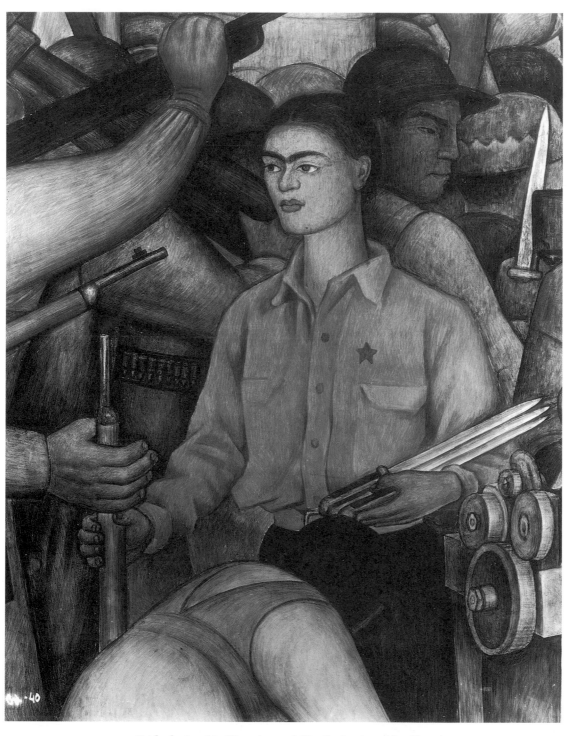

Frida depicted in Rivera's mural *Distributing Arms* (detail),
Ministry of Public Education, 1928

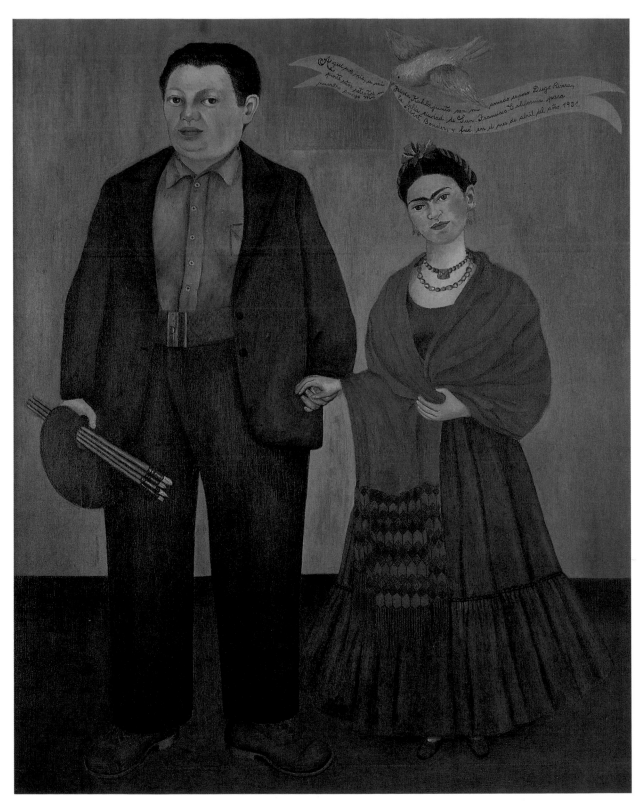

Frida and Diego Rivera
1931

The Other Accident

"When I was seventeen, Diego began to fall in love with me," Frida once explained to a journalist (subtracting three years from her age). "My father didn't like him because he was a Communist and because they said he looked like a fat, fat, fat Breughel. They said it was like an elephant marrying a dove. Nevertheless, I arranged everything in the Coyoacán town hall for us to be married on the twenty-first of August, 1929." To a friend, Frida said, "I have suffered two serious accidents in my life, one in which a streetcar ran over me.... The other accident is Diego."

It was Diego Rivera's first legal marriage, although there had been many women in his life and two other long-term relationships. The Russian artist Angelina Beloff lived with him as his common-law wife for ten years in Paris during the 1910s; she bore him a son, who died at an early age. Another lover, Marievna Vorobiev-Stebelska, also had a child by him, a daughter, whom he did not acknowledge as his own for many years. In 1922 in a church ceremony, Diego married the beautiful Mexican Lupe Marín, with whom he had two daughters. According to Mexican law, which required a civil ceremony, this union was not legal, but it was considered a serious commitment by the couple. However, a divorce was not necessary when Diego decided to marry Frida.

"I borrowed petticoats, a blouse, and a rebozo from the maid, fixed the special apparatus on my foot so it wouldn't be noticeable, and we were married. Nobody went to the wedding, only my father, who said to Diego, 'Now, look, my daughter is a sick person and all her life she's going to be sick. She's intelligent but not pretty. Think it over awhile if you like, and if you still wish to marry her, marry her, I give you my permission.'" According to Diego, Frida's father added he rightfully had to warn him that she was *un demonio*, a devil.

"Then they gave us a big party in Roberto Montenegro's house. Diego got horrendously drunk on tequila, waved his pistol about, broke some man's little finger, and destroyed some other things. Afterward, we got mad at each other; I left crying and went home. A few days went by and Diego came to get me and took me to his house at 104 Reforma."

Tina Modotti wrote to Edward Weston in September 1929: "Had I not told you Diego had gotten married? I intended to. A lovely nineteen-year-old girl, of German father and Mexican mother; a painter herself." Modotti added in Spanish, "A ver que sale!" (Let's see how it works out!)

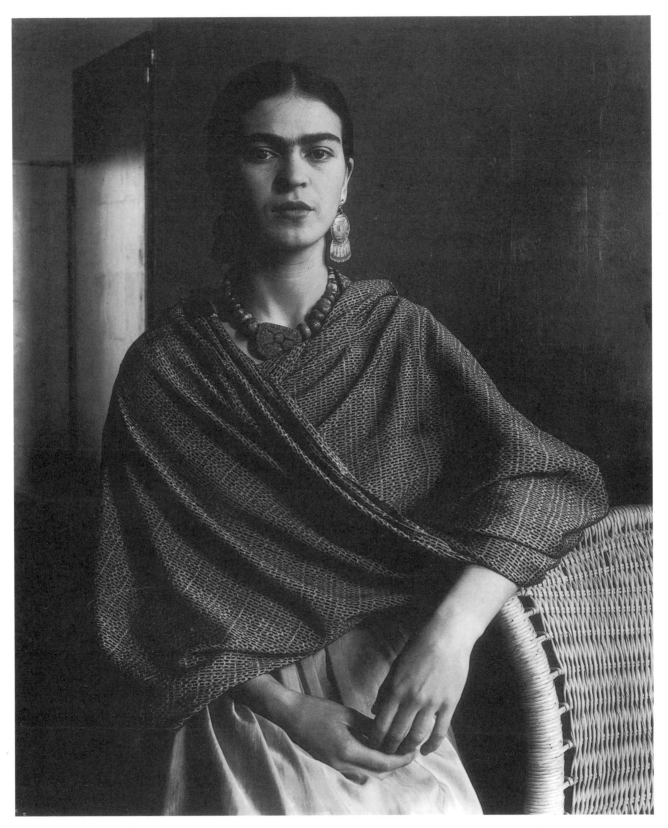

Frida, c. 1930

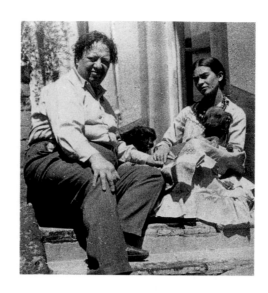

Many others were struck by the incongruity of the petite, young Frida marrying the overweight, middle-aged artist. When her school friends heard about her marriage, they were shocked and surprised, considering it *una cosa monstruosa*, a hideous thing. But Frida was the last unmarried daughter of ill parents in sad financial straits. Her decision had pragmatic as well as romantic repercussions; in fact, Diego paid off the mortgage on her parents' home.

Certainly the striking pair's marriage, reported widely in the international press, offered Frida an opportunity to move not only in Mexican but leading European and American artistic and intellectual circles; she relished the contacts she made and the attention she received as the wife of a famous artist. But perhaps ultimately she was attracted by an attribute described by each of Diego's previous companions, his dynamism, by which he vitalized everything and everyone who came near him. He was possessed of a great and genuine warmth along with a capacity for charmingly tender gestures.

Frida began her married life in Diego's house in the first block of Mexico City's Avenida Reforma. In an interview she said, "For furniture we had a narrow bed, a dining set that Frances Toor (editor of *Mexican Folkways*) gave us with a long black table, and a little yellow kitchen table that my mother gave us. We arranged it out of the way in one corner for the collection of archaeological pieces. We couldn't have a child, and I cried inconsolably, but I distracted myself fixing meals, cleaning house, painting at times, and going along with Diego each day to the scaffolds. He really liked me to come along bringing his lunch in a basket covered with flowers."

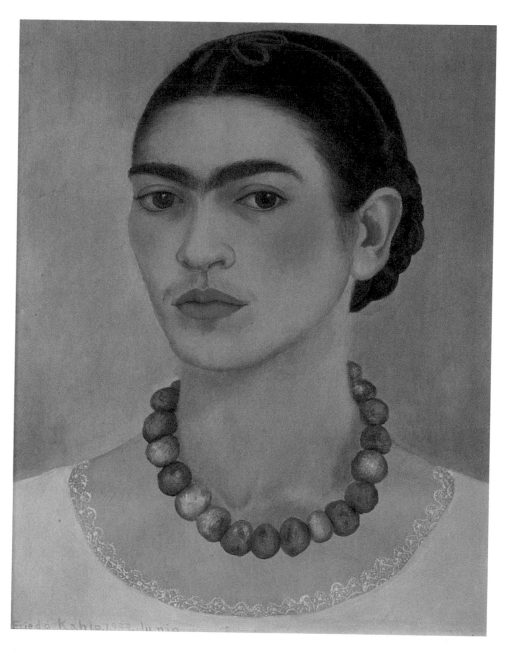

Self-Portrait with Necklace
1933

Hospitably, if unpredictably, Diego's ex-wife Lupe Marín took the young newlywed under her wing, going with her to buy pots and pans and kitchen things, then teaching her to prepare Diego's favorite dishes. Frida painted Lupe's portrait as a gift in thanks for the cooking lessons.

Shortly after their marriage, the couple moved to Cuernavaca, where Diego had been commissioned by U.S. Ambassador Dwight W. Morrow to paint a mural in the historic colonial palace of Hernan Cortés. While Diego tackled long work days, Frida passed the time visiting neighboring villages with a friend, Luis Cardoza y Aragón, who was living with them. He remembers with affection, "Frida was what she always was, a marvelous woman. There was a spark in her that was growing and beginning to light up her canvases, to light up her life and, in turn, the lives of others."

In the fall of 1930, Frida for the first time traveled out of Mexico. She and Diego went to San Francisco, where he had commissions to paint two murals. While he worked on the scaffolds at the Pacific Stock Exchange Luncheon Club and the California School of Fine Arts (now the San Francisco Art Institute), she explored the streets of Chinatown and the North Beach area near their studio living quarters. She visited with the wives of his assistants and other artists they knew. Together they often played "Exquisite Cadavers," drawing by turns on a piece of paper folded in equal sections, each player inventing a part of the human body without knowing what had been drawn by the preceding person. When the paper was unfolded, the hilarious result was revealed, to which Frida always added the most erotic and audacious details.

In San Francisco Frida and Diego attracted the attention not only of artist friends but of wealthy art patrons and prominent business figures, beginning the torrent of adulation, praise, and later, controversy that would accompany Diego throughout his U.S. visit. They made a dramatic couple: the dark and slender beauty in long Mexican dress with her elaborate jewelry, the genial, towering fat man in rumpled suit and broad-brimmed hat. The press loved them, and newspaper coverage was extensive wherever they went.

Meanwhile, Frida was sketching and making pictures of herself and of friends. She painted a double portrait of herself and Diego for Albert Bender, an influential businessman and philanthropist who had intervened with the State Department to get Diego an entry visa in spite of his Communist ties; he also helped them

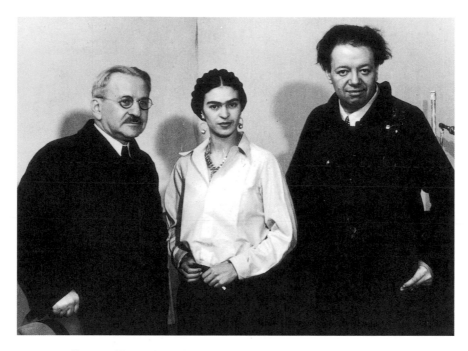

Albert Kahn, Frida, and Diego at the Detroit Institute of Arts, 1932

financially by purchasing Diego's work and by encouraging friends to do so. In one corner of the double portrait, using a motif from Mexican folk art, Frida painted on a ribbon held in the beak of a dove, "Here you see us, I, Frida Kahlo, with my adored husband. I painted these portraits in the beautiful city of San Francisco, California, for our friend, Mr. Albert Bender, and it was in the month of April in the year 1931."

During the six months they spent in San Francisco, Frida was briefly hospitalized for a problem with her foot. Her physician, Dr. Leo Eloesser, became a lifelong friend and adviser. She painted *Portrait of Dr. Leo Eloesser* for him in thanks and perhaps as compensation.

After a short trip to Mexico in the summer of 1931, the Riveras returned to the United States, this time to New York for a major exhibition of Diego's work at the Museum of Modern Art, only the second one-person show held there. Once again the center of attention, Diego and Frida were feted by New York's business and art elite, including John D. and Abby Rockefeller, who became patrons. Frida at first took a dislike to the crowded city, and Diego had little time for her as he prepared for the exhibition's opening. But as the months went by, Frida began to meet and enjoy new friends with whom she could explore Manhattan.

Diego's career next took them, in the spring of 1932, to Michigan where the Detroit Arts Commission had invited him to create an extensive series of murals at the Detroit Institute of Arts.

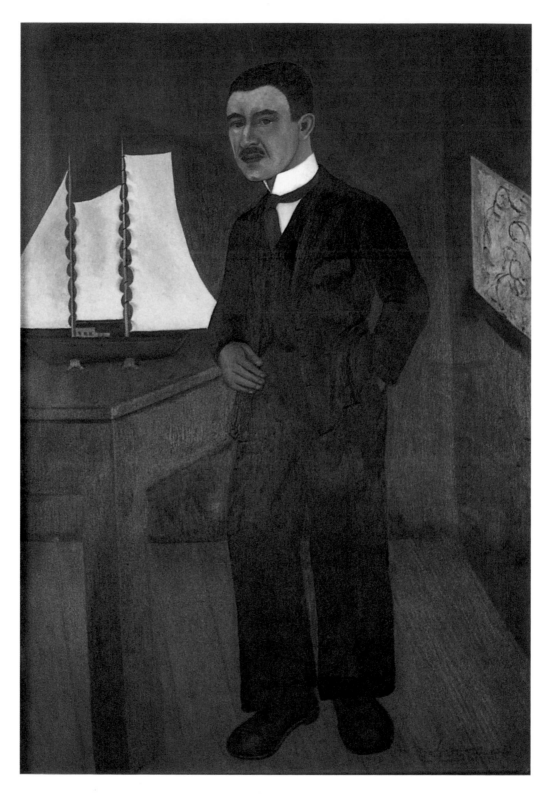

Portrait of Dr. Leo Eloesser
1931

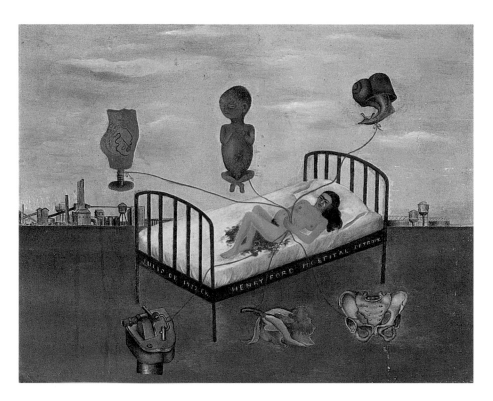

Henry Ford Hospital
1932

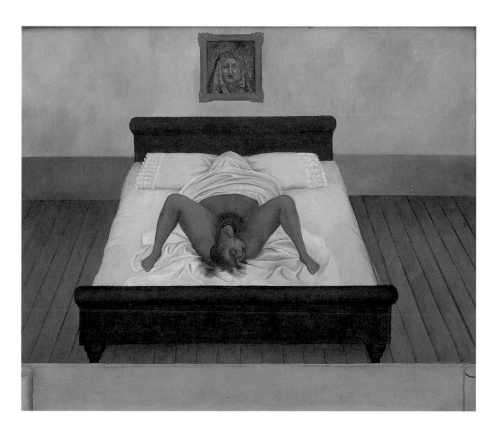

My Birth
1932

Diego again immersed himself in his work, putting in long, arduous days with his assistants. It was a lonely time for Frida. Her stay in Detroit was also marked by a serious medical problem. On the fourth of July, in the midst of severe hemorrhaging, she was rushed to Henry Ford Hospital.

In the retelling, and in a painting, Frida claimed to have lost a baby. Her extreme isolation in a strange land, coupled with her apparently conflicted emotions about having a child, is movingly recalled in *Henry Ford Hospital* (1932). She expressed the dramatic event in this small painting with strongly contrasted colors in a simple but effective style that disregards scale or proportion.

Later that year Frida made a brief trip back to Mexico on another sad occasion, the death of her mother, after which she painted *My Birth* (1932). She was creating many works now, experimenting with techniques, painting on tin, making lithographs, even trying her hand at fresco. More noteworthy was a change in content: her work was beginning to emphasize terror, suffering, wounds, and pain.

Homesick for her family and friends, Frida yearned to return permanently to Mexico. But when Diego completed the Detroit murals, they moved back to New York where he was installing a large mural at Rockefeller Center. When work was nearing completion, Diego was discharged from the project because he refused Nelson Rockefeller's request that he remove a portrait of Lenin from the composition. The clash generated world-wide publicity, to Diego's great pleasure, but the mural was eventually destroyed.

Diego and Frida stayed in New York a few months longer, during which time he did a number of other murals. Frida painted the ironic *My Dress Hangs There* (*New York*) (1933), in which a Tehuantepec costume hangs on a clothesline strung between two classic columns. They support American icons, a white enamel toilet and a gilt athletic trophy. No life force vitalizes the intensely colored canvas: Frida herself is no longer in New York.

Diego finally and reluctantly agreed to return to Mexico in late 1933. In a few months they were settled in San Angel in the novel twin houses designed for them by their artist friend Juan O'Gorman. Built in a functional style, the larger building was Diego's studio; the smaller one, living space and Frida's studio. One house was blue, the other bright pink, with a light blue stairway and wrought ironwork painted red. A bridge at the level of the rooftop

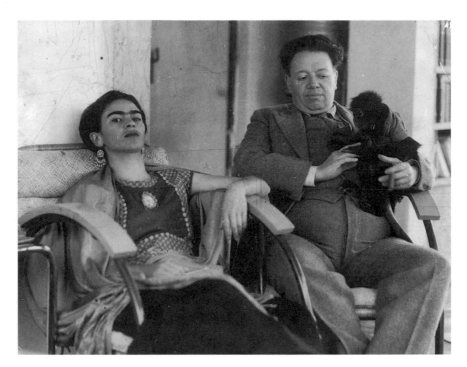

Frida and Diego with one of their pet monkeys, n.d.

terrace connected the two structures, and encircling both houses like a fence, a line of gray-green cactus contrasted beautifully with the brilliant colors of the painted buildings.

Diego told journalists that the houses had been designed to "guarantee domestic tranquility," but the couple found little peace. Diego's displeasure at being forced to return to Mexico was visible and audible for a long time. Something worse marred the domestic scene, an event that perhaps caused Frida the greatest agony of her life. During 1934 Diego began a love affair with her younger sister, Cristina.

Frida was aware that Diego spread his affections around, and she excused him, saying, "How would I be able to love someone who wasn't attractive to other women?" She developed a defense: at the first pang of jealousy or sense of abandonment, she would pretend to others that she and Diego had an ideal union of unbroken devotion, despite his numerous casual and short-lived adventures with the admiring women who flocked around him. But the affair with Cristina, Frida's dearest family member and confidante, was too much. Frida took an apartment in Mexico City for a time, trying in vain to find an independent life.

But for all the strength of her personality, Frida felt insecure without Diego to praise her talents, cleverness, and beauty. When he withdrew from her, feelings of abandonment overwhelmed her. In

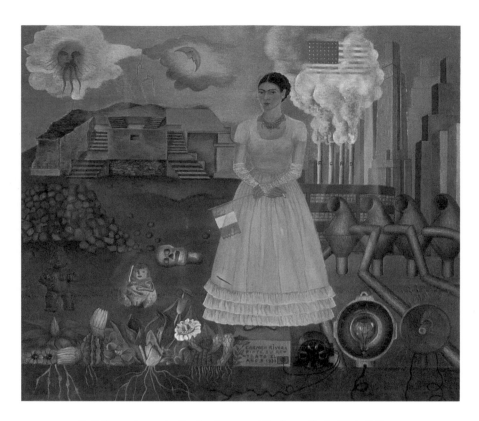

Self-Portrait on the Border between Mexico and the United States
1932

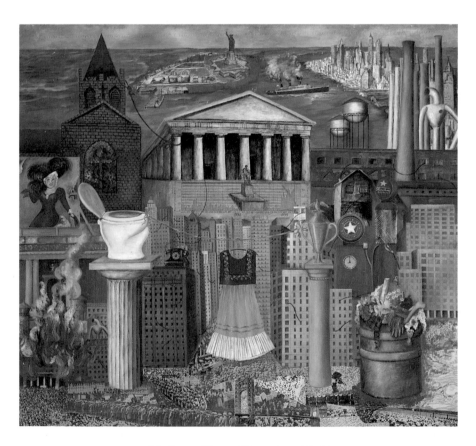

My Dress Hangs There (New York)
1933

Portrait of Cristina, My Sister
1928

July 1935, she fled to New York. There she resolved to accept her husband's wayward behavior; as she wrote Diego, she "loved him more than her own skin." According to her husband, she returned to him in Mexico "with slightly diminished pride, but not with diminished love." They established a pact that allowed frequent escapades for both, but with the mutual understanding that the affairs were something apart from their own special and intimate relationship.

Eventually, Frida was reconciled with Cristina and seemed to pardon her as well as Diego. What remained to remind her of her immense grief was a picture she painted in 1935, *A Few Small Nips*. It was based on a story of a man who murdered his companion by stabbing her repeatedly; when confronted with the horror of what he had done, he excused himself by explaining, "But I only gave her a few small nips." In a preliminary sketch for the painting, Frida drew a dove holding a ribbon in its beak bearing a line from a popular song, "My sweetie doesn't love me anymore." In the finished painting—a gruesome, blood-soaked scene in a room with pale pink walls—a delicate white dove and a black swallow lyrically suspend a ribbon that says "Unos cuantos piquetitos!" (A few small nips!). Years later, Frida extended the spilled blood depicted in the canvas to the picture's frame.

After her husband's involvement with her sister, Frida herself engaged in a number of love affairs of varying duration and intensity. Some friends believed these dalliances were merely in retaliation for Diego's transgressions; others felt they were expressions of her own sexual amorality. Whichever they were, she plunged into each liaison with a headlong passion, which typically extinguished itself rapidly. These fiery, fleeting relationships included the American sculptor Isamu Noguchi, who came to Mexico to do a mural; at least two Spanish refugees whom the Riveras helped during their first years of exile in Mexico; Heinz Berggruen, whom she met in San Francisco; and the painter Ignacio Aguirre. There were also a number of trysts with women.

One affair of great consequence to Frida was with Nickolas Muray, a well-known Hungarian photographer who made some of the most beautiful photographs of Frida. Although Frida was jealous and hurt when Muray's interest turned to another woman, a letter from Muray makes it clear that Frida never abandoned her attachment to Diego: "I knew New York only filled the bill as a

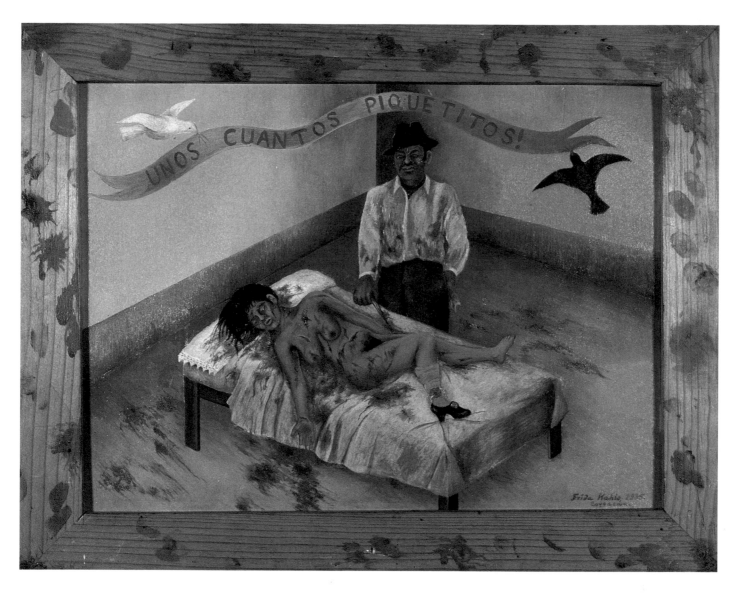

A Few Small Nips
1935

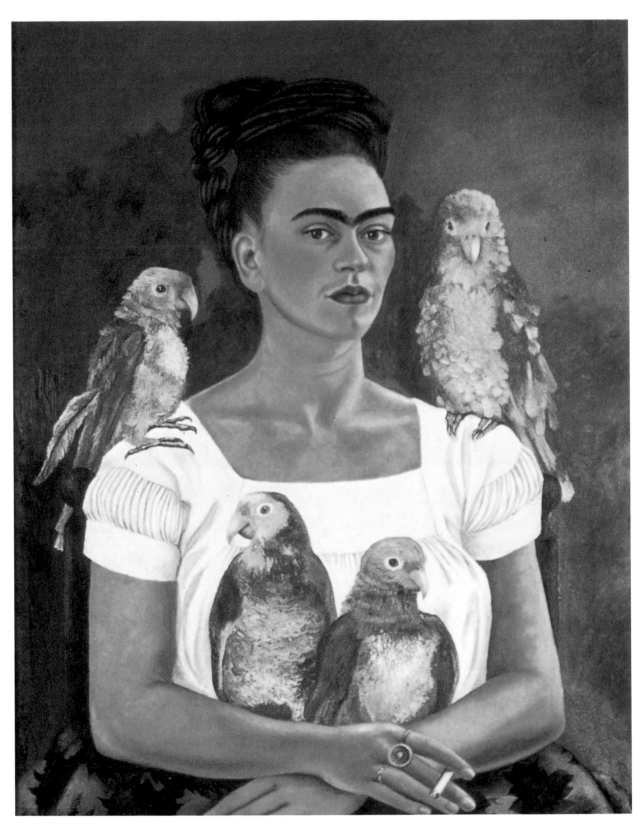

My Parrots and I
c. 1941

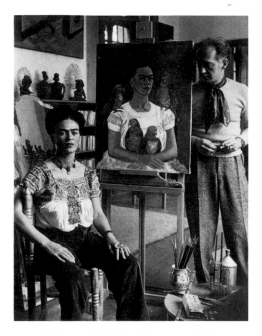

Frida and Nickolas Muray, c. 1939

temporary substitute, and I hope you found your haven intact on your return. Of the three of us there was only two of you. I always felt that. Your tears told me that when you heard his voice. The one of me is eternally grateful for the Happiness that the half of you so generously gave."

Even though Frida's liaisons allowed her to reaffirm her power of attraction and to counteract the pain of her husband's escapades, her primary and exclusive love for Diego never abated. Once the flood of romantic passion had ebbed, she wanted to return to the firm ground of her true love, to Diego.

Perhaps Frida's most fascinating and unlikely affair was with Leon Trotsky. The Russian leader had been exiled from the Soviet Union by Joseph Stalin in 1929, and after a few years in Turkey, France, and Norway, he found himself with an expired Turkish passport, no government wanting to admit him, and in urgent need of political asylum. Friends asked Rivera to intervene with the Mexican government. Diego was not only successful in convincing President Lázaro Cárdenas to grant asylum, but he offered Frida's Casa Azul as a permanent residence for the Trotskys.

In January 1937 Trotsky and his wife, Natalia Sedova, arrived by steamship at the Mexican port of Tampico. The couple settled in at the house in Coyoacán, which had been modified for their safety into a virtual fortress with organized shifts of guards, barricades, covered windows, and alarm systems.

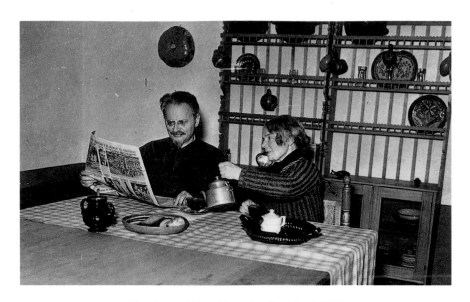

Trotsky and his wife at the Casa Azul, 1938

Trotsky was a vigorous man, fifty-seven years old, tall, dashing, and full of energy. According to Jean van Heijenoort, Trotsky's secretary, Frida and Trotsky's interest in one another was soon apparent to many. Frida behaved coquettishly, frequently using the word "love" when speaking to him. She communicated easily with him in English, which had the advantage of excluding his wife, who didn't understand the language. Trotsky slipped letters into books he loaned to Frida, and they held clandestine meetings in Cristina Kahlo's nearby house.

By June Natalia Sedova took notice of the situation, and tension began to build. Trotsky and Natalia decided to separate for a while, and in July he moved to the hacienda San Juan Hueyapan, some distance from the capital, accompanied by a bodyguard and one of Diego's drivers. A few days later, Frida arrived to visit him, and at this meeting they most likely decided to end their affair. Within a few weeks Trotsky was writing to his wife of Frida, "She is nothing to me."

While still on friendly terms with Trotsky, Frida painted a self-portrait for him. It shows her standing between two curtains, holding a piece of paper that says, "To Trotsky with great affection, I dedicate this painting November 7, 1937. Frida Kahlo, in San Angel, Mexico." The date was both Trotsky's birthday and the anniversary of the October Bolshevik Revolution according to the Gregorian calendar.

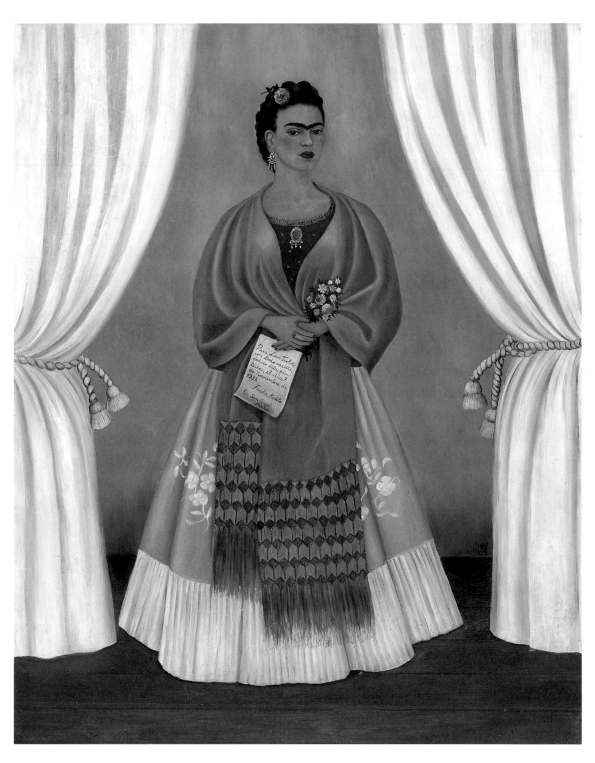

Self-Portrait Dedicated to Leon Trotsky (Between the Curtains)
1937

These years, in which Frida met a stimulating parade of international personalities and withstood the emotional somersaults of her sexual relationships, were among the most productive of her artistic career. Besides the self-portrait she dedicated to Trotsky, she painted *The Deceased Dimas* (1937), *My Nurse and I* (1937) (one of Frida's favorites), *What the Water Gave Me* (1938), *Self-Portrait (Fulang Chang and I)* (1937), and other works. She exhibited *My Grandparents, My Parents, and I (Family Tree)* (1936) in a group show at the National Autonomous University of Mexico's Department of Social Action. She was busy preparing for her first solo exhibition, to be held in November 1938 at the Julian Levy Gallery in New York, where she traveled toward the end of the year. Shortly before, she had been thrilled by the first sale of her pictures to the actor and collector Edward G. Robinson, who was visiting Mexico. Until then she had been content to give away her paintings, but now an American connoisseur had paid for her work. Frida arrived in New York in a confident mood. Her exhibition was well received by public and critics, and she sold a fair number of pictures.

At the close of the gallery show, Frida considered going to Paris where André Breton, the Surrealist writer, was organizing an exhibition called *Mexique*, which would feature pre-Hispanic figures, folk art, ex-votos, seventeen of Frida's pictures, and photographs by Manuel Alvarez Bravo. She was unsure of being away from Diego, but he wrote to her in December 1938: "Don't be foolish. I don't want you to lose the opportunity to go to Paris because of me....If you really want to please me, you can be sure that nothing would make me happier than knowing you were enjoying yourself. And you, my dearest little sweetheart, you deserve it all....I don't blame them for liking Frida, because I, too, like you more than anything."

She traveled to Paris, and as always, her exotic clothing and array of unusual jewelry turned heads wherever she went. Frida liked to say that her unconventional appearance created such a sensation that it inspired magazine cover designs and haute couture gowns.

In Paris Frida renewed her friendship with André Breton and his wife. The Bretons had visited Mexico for a lecture tour in 1938, and became acquainted with the Riveras then. Breton saw Frida's art as Surrealist and claimed her as one of his group, saying of her work, "The promises of fantasy are filled with greater splendor by reality itself!" She also met other famous painters of the period—Pablo

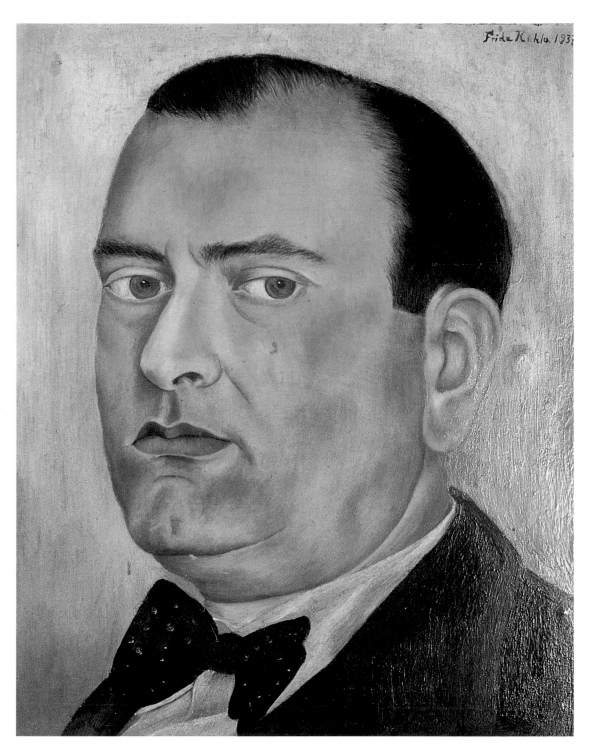

Portrait of Alberto Misrachi
1937

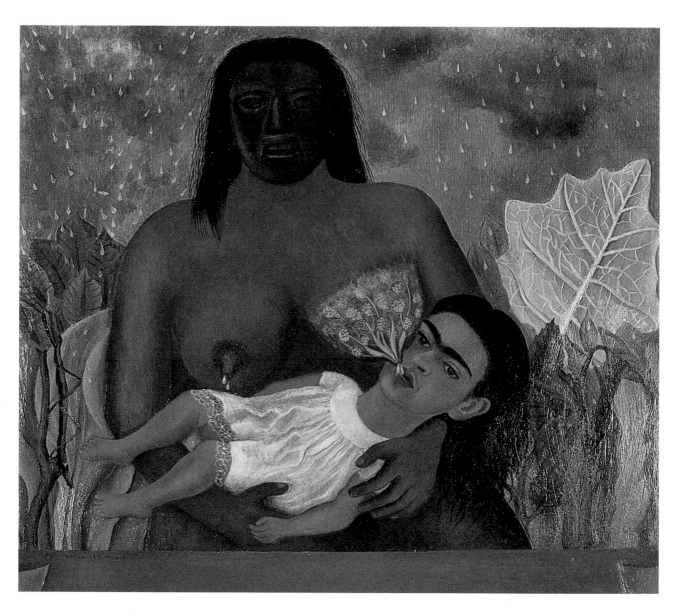

My Nurse and I
1937

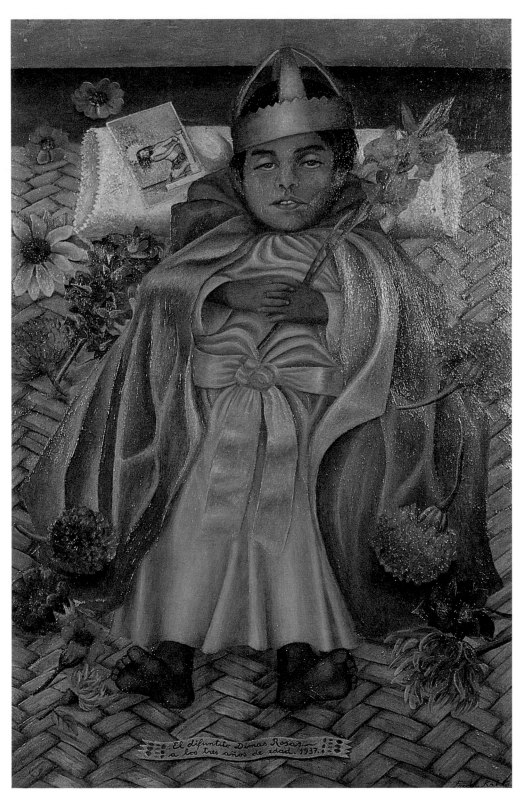

El difuntito Dimas Rosas
a los tres años de edad. 1937.

The Deceased Dimas
1937

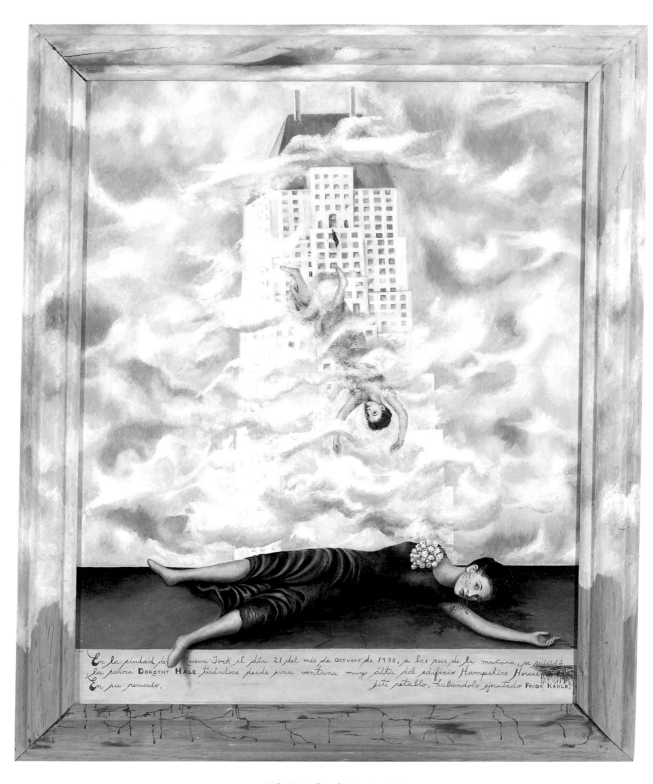

The Suicide of Dorothy Hale
1938–39

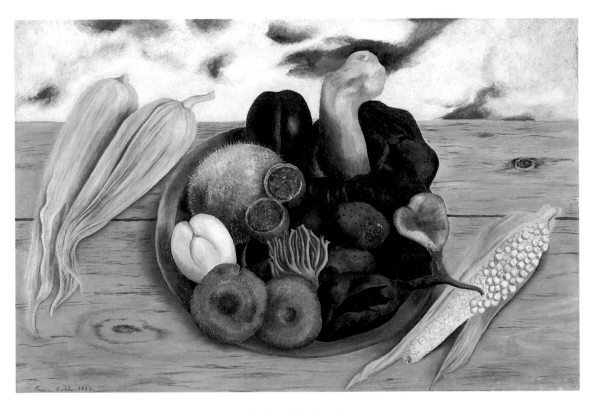

Fruits of the Earth
1938

Flower of Life
1938

Cactus Fruit
1937

Picasso, Marcel Duchamp, Wolfgang Paalen, Wassily Kandinsky, and others. They took her to the restaurants where they held their salons, boosting her ego with the warm tribute paid to her painting and her beauty. She enjoyed particular attentions from Picasso, who taught her songs, praised her paintings, and presented her with a gift of earrings in the form of enormous hands. She wore them frequently and painted them, in somewhat modified form, in two self-portraits (1940 and 1946).

Another accolade came Frida's way in Paris. The Louvre purchased a self-portrait, *The Frame* (c. 1938), from the *Mexique* exhibition. Diego spoke proudly of this, saying that none of the three great Mexican muralists, Orozco, Siqueiros, and himself, had been so honored.

Frida arrived home in April 1939, feeling more sure of herself as an artist than ever before. Her pictures were selling and had merited praise from the most severe critics; she was not the least bit disturbed by critical comments from those horrified by her sanguinary and shocking themes. Frida looked forward to being truly independent and supporting herself by painting. She was feeling equally secure about her attractiveness as a mature woman, one who captivated prominent industrialists and distinguished political figures as well as famous artists and writers.

But Frida's new-found security collapsed soon after her return, when she was confronted with Diego's request for a divorce. Manuel González Ramírez, one of Frida's Cachucha friends from the Prepa, acted as her lawyer in preparing the papers. "I arranged the dissolution of the bonds, and I knew very well how sad she felt about the separation," he declared. "She was lost in a limbo bordering on despair."

A single reason for the divorce is hard to find. Perhaps Diego found out about her affair with Trotsky. Perhaps Frida expressed displeasure at Diego's dalliance with American film star Paulette Goddard, who was staying at the San Angel Inn right across from their house. In a letter to a friend, Frida blamed Diego's ex-wife, Lupe Marín, for causing the divorce. Rivera's statement to journalists explained it as "purely a matter of legal convenience in the style of modern times. We did it for the purpose of bettering Frida's legal position. There are no sentimental, artistic, or economic reasons."

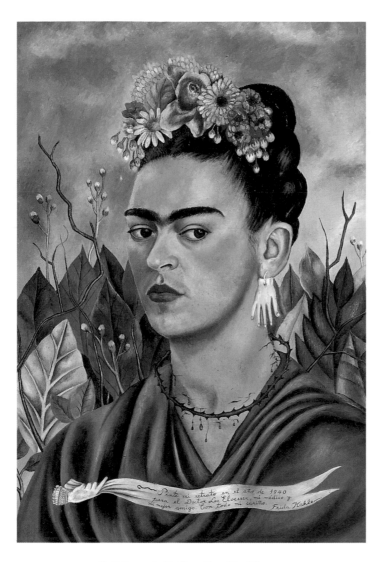

Self-Portrait Dedicated to Dr. Eloesser
1940

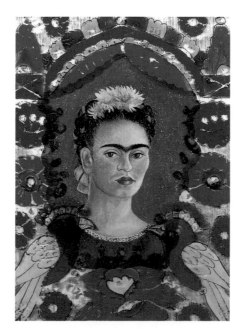

Self-Portrait (The Frame)
c. 1938

Frida was devastated, and she became deeply depressed. Suddenly living alone, she was compelled to produce enough work to support herself. Paradoxically, the mental anguish and turmoil of her personal predicament resulted in some of her finest painting. The only large-scale canvases she ever made were done at this time: *The Two Fridas* (1939), a double self-portrait painted a few months after her separation and in the worst moments of her emotional crisis, and *The Wounded Table* (1940), a self-portrait in which Frida is embraced by a bizarre, oversized Judas figure, while a macabre skeleton twirls a lock of her hair.

Both paintings were exhibited in January 1940 in Mexico City at the important *International Surrealism Exhibition* in Inés Amor's Gallery of Mexican Art. *The Two Fridas* was next exhibited in New York in the Museum of Modern Art's exhibition *Twenty Centuries of Mexican Art*. Not until seven years later was *The Two Fridas* sold, to the Institute of Fine Arts in Mexico. *The Wounded Table*, last exhibited in Warsaw in 1955, reportedly was sent to the Soviet Union as a gift from the Mexican Communist party; its whereabouts are now unknown.

Another fine self-portrait is *Self-Portrait with Cropped Hair* (1940). It was inspired by Frida's defiant act of cutting her long hair, which Diego adored. The lyrics and notes of a popular song are displayed across the top: "Look, if I used to love you, it was because of your hair, now that you're *pelona*, I don't love you anymore." *Pelona*, a slang word of the sort Frida liked to use, means bald or shorn.

Frida's generally poor physical condition was exacerbated by extremely heavy drinking, and after the divorce her health deteriorated rapidly. She continued to suffer from the circulatory problems that had plagued her since 1934, when five joints on the toes of her right foot had been removed. General fatigue and back pain were always with her.

In May 1940, a pro-Stalinist group involving the artist Siqueiros made an unsuccessful attack on Trotsky's life. A second attempt, on August 20, succeeded. Trotsky was fatally hit on the head with a climbing ax by a Soviet agent, Ramón Mercader. Since Frida had known Mercader in Paris as well as Mexico, she was among the many suspected accomplices. She and her sister Cristina were questioned for hours by the police.

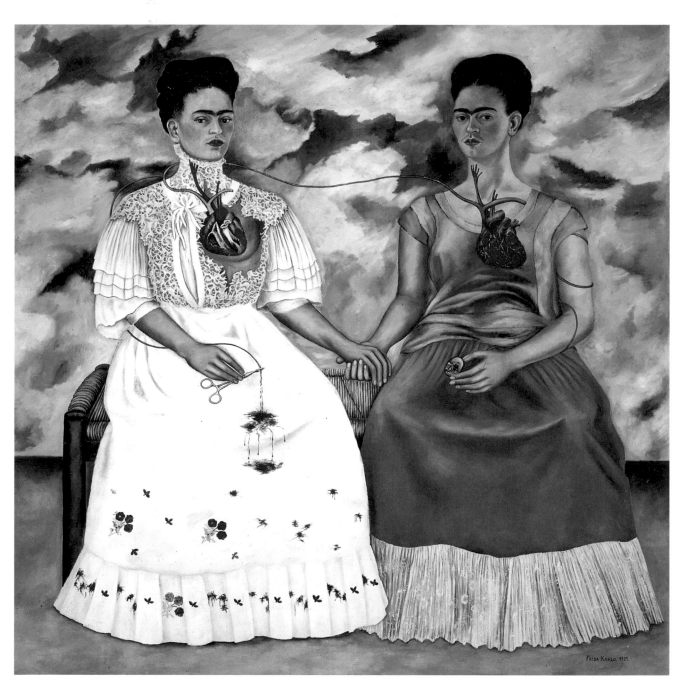

The Two Fridas
1939

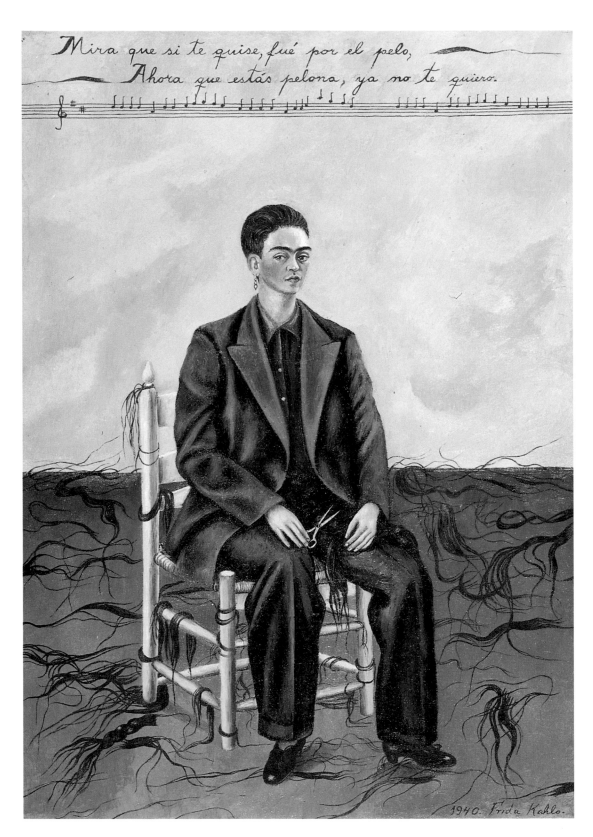

Self-Portrait with Cropped Hair
1940

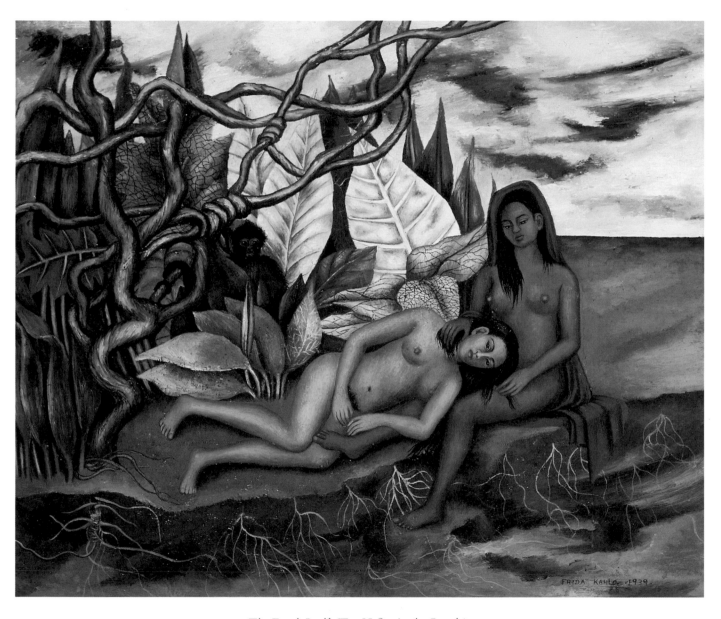

The Earth Itself (Two Nudes in the Jungle)
1939

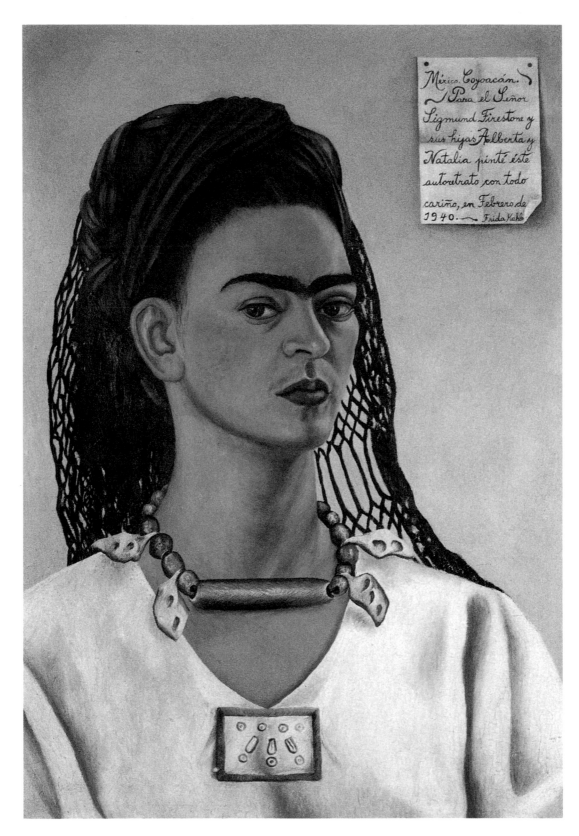

Self-Portrait Dedicated to Sigmund Firestone
1940

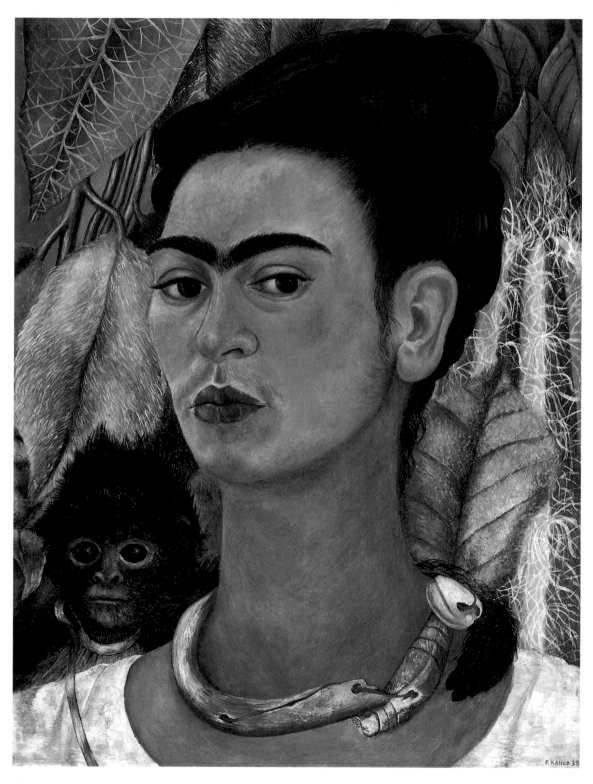

Self-Portrait with Monkey
1938

The stress of the police interrogation only intensified the gravity of Frida's already weakened physical condition. Diego was in San Francisco, painting a mural. When he heard how ill Frida was, he suggested that she consult with Dr. Eloesser, who had followed her medical history for the last decade. In September Frida flew to San Francisco. Eloesser prescribed absolute rest, a special nutritious diet, electro and calcium therapies, and abstinence from alcohol. This treatment, combined with Diego's tender sympathy, improved her health tremendously.

Eloesser was instrumental in more than the momentary improvement of Frida's physical well-being. He urged the couple to reconcile, and on Diego's fifty-fourth birthday, December 8, 1940, they were married again. Frida went home to Mexico two weeks later, followed in a few months by Diego. They were ready to renew their life as partners.

But it was not the same Frida going back into the marriage. Despite her continued enjoyment of public attention, she was no longer an impulsive, flirtatious, and charming adolescent. The reality of her thirty-three years must have confronted her. Frida rejoined Diego with her eyes open, accepting the complexities of her own personality as well as his. She began to craft her own ambiance, a personal world apart from the one she shared with her husband.

Frida was so completely convinced of the necessity for this change that shortly after her return from San Francisco she moved back to Coyoacán to the Casa Azul, determined to build an independent life for herself. There she created the rest of her pictorial autobiography, never going back to stay in the studio next door to her husband's. Diego could live with her or not, sleep in Coyoacán or at his studio in San Angel. Frida would not move out of her refuge again.

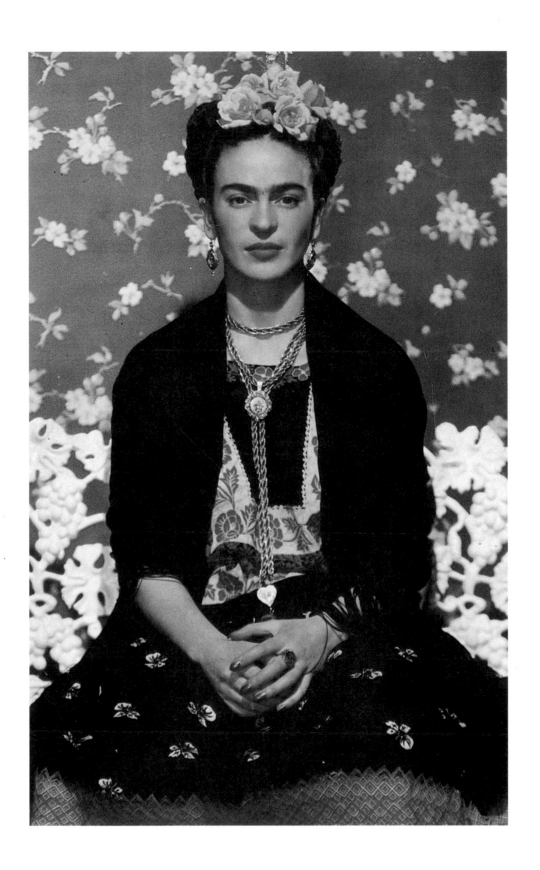

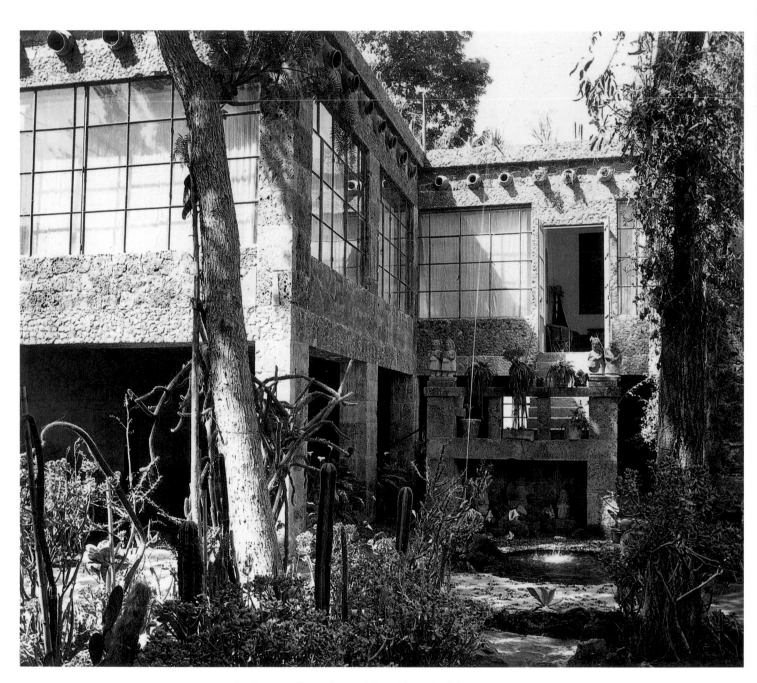

The Casa Azul's garden and the addition built by Rivera, c. 1952

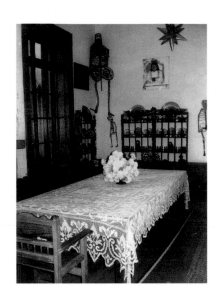

The Colors of Life

The elegant furnishings of the Casa Azul—its lace curtains, Persian carpets, French-style furniture, and porcelain figurines—had long since been lost or sold to settle debts. When Frida returned in 1941 to make the family home her residence, she set about arranging its decor to suit her unique personality.

Inside the house, Frida had the wide planks of the floor painted a strong yellow. On the walls and in cupboards she arranged her distinctive collection of art objects and curios. There were pre-Columbian figurines, pieces of folk art, and an array of toys and dolls. Frida loved to receive presents and often shamelessly asked friends to bring her toys to add to her treasured childhood collection. At the other extreme, she displayed on a bookshelf a jar containing a fetus in formaldehyde, which she presented to visitors as her own still-born child.

Larger-than-life Judas figures invaded patios and rooms. These gaudily painted papier-mâché effigies, traditional folk art objects made to be burned in the street during Lent, at times wound up dressed in Frida's shawls and petticoats. A skeleton hung next to her bed and was the object of an affectionate greeting every morning. Frida, grasping its hand, would say, "Hola, 'mana!" (Hi there, sis!) to start the day. An even larger skeleton, with strings of

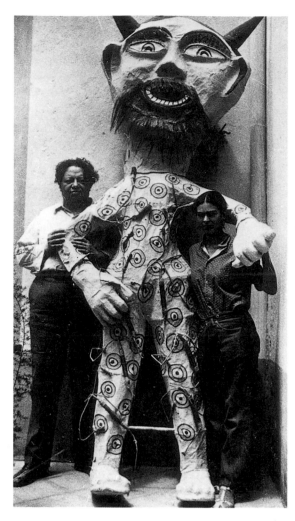

Diego and Frida with a Judas figure

fireworks crisscrossed over his ribs, was atop the canopy of Frida's bed, reclining on two pillows. "Your lover," Diego used to call the insouciant symbol of death.

The year before, Diego had added to the Casa Azul a wing made of volcanic rock and decorated with stone mosaics, much as he would later build Anahuacalli, his anthropological museum. The largest of the new rooms was a studio for Frida; Diego also constructed a small pyramid in the garden. There parakeets, macaws, hens, and sparrows lived among the plants and flowers that Frida tended. Her pet animals roamed about freely: the little deer Granizo; the parrot Bonito; the favorite dog señor Xólotl, a hairless Mexican *ixquintle*; the cherished spider monkeys Fulang Chang and Caimito de Guayabal; and her eloquently named eagle, Gertrudis Caca Blanca (Gertrude White Shit). The Judas figures and exotic plants and animals, her constant companions, appear in many of Frida's paintings.

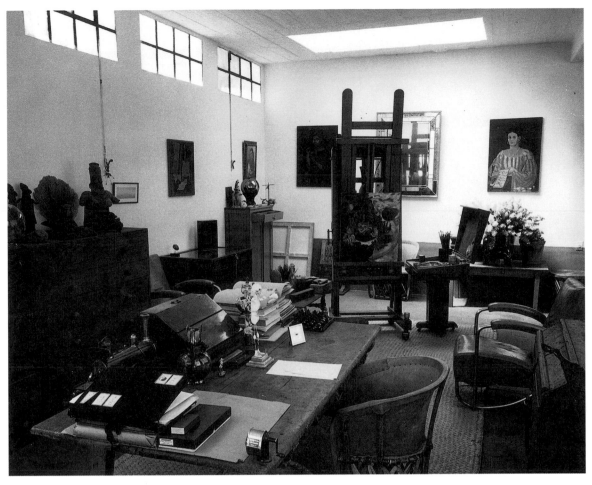

Frida's studio, c. 1949

Pyramid constructed by Diego in the garden at the Casa Azul

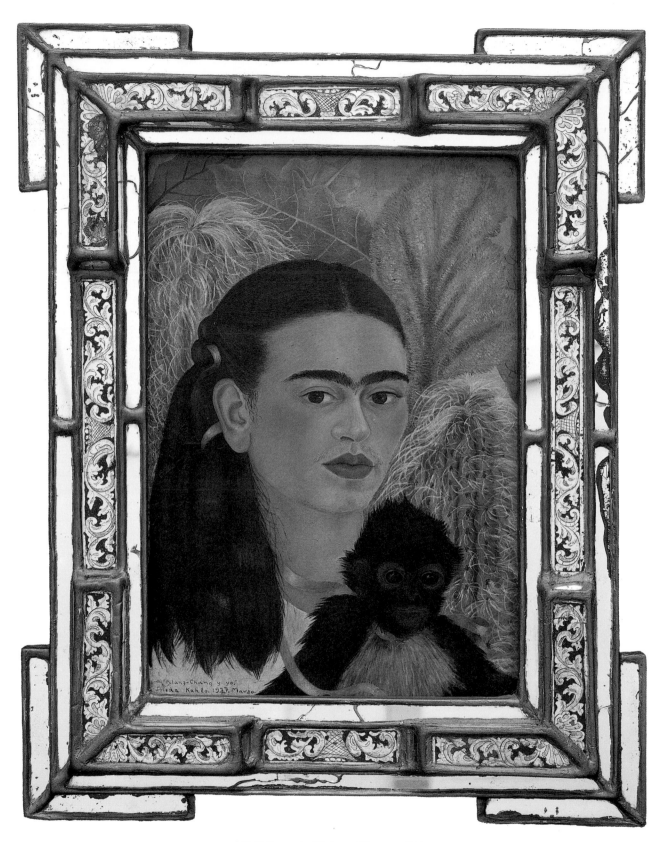

Self-Portrait (Fulang Chang and I)
1937

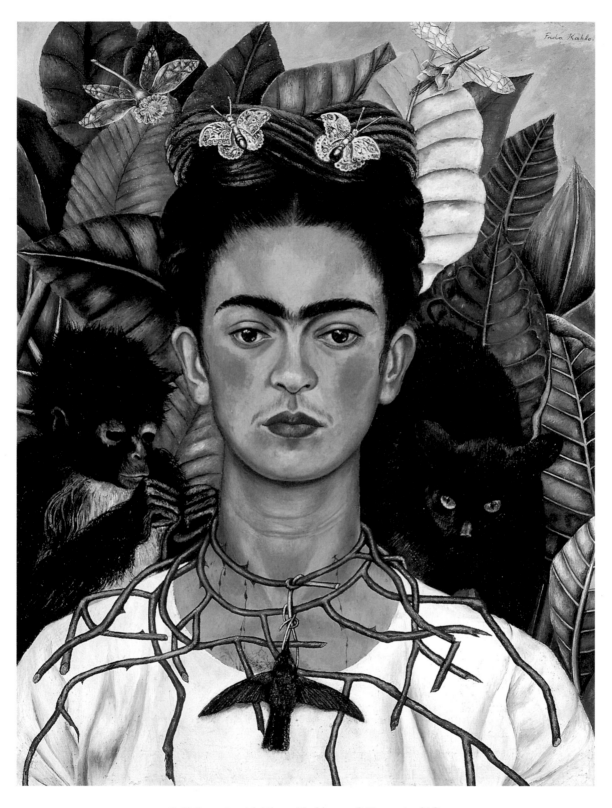

Self-Portrait with Thorn Necklace and Hummingbird
1940

Frida's bed

Upstairs, Frida's bed was often her world for long periods of time, and around it she gathered an array of necessary or attractive items. Overhead, she could see her reflected image in the canopy's mirror. Lying in bed, she could paint with the ingenious wooden easel that her mother had ordered built for her long ago. Her headboard was completely covered with photographs of people dear to her — her sisters and father, her family grouped around her when she was a child, her niece and nephew, her close friend Pita Amor. Alongside hung portraits of Marx, Engels, Lenin, Stalin, and Mao. Nearby were her collections of toys, pre-Hispanic pieces, and mounted butterflies. Paintbrushes, pencils, her diary, and assorted bright-hued objects completed the decoration. The room was redolent of medicines and perfume.

Frida was often heard to say, "I look like a lot of people and a few things," as if everything that made up her personal appearance was a matter of chance. In fact, it was quite the opposite. Dressing each day was an almost ceremonial affair during which she would try innumerable combinations of blouses and skirts. Her clothes were always immaculately clean and freshly ironed; she was meticulous about the appearance of her pleated petticoats, pure white and starched. She wore native Mexican costumes long after her sophisticated friends had given up this nationalistic gesture, in part for the long skirts that hid her thin leg and orthopedic shoe.

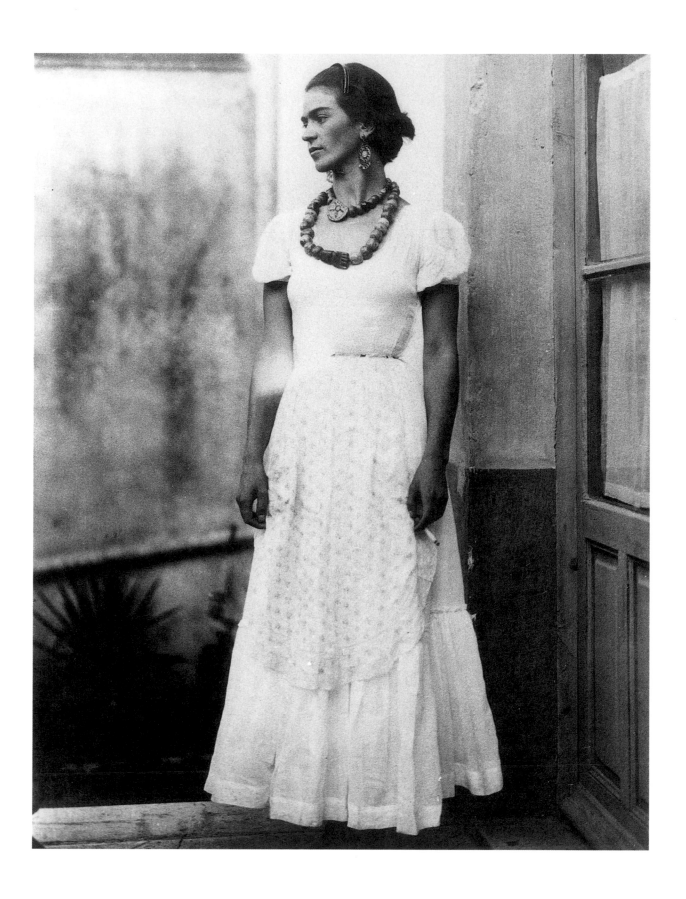

Frida's favorite costume was from the Isthmus of Tehuantepec, and she twice painted herself wearing it, in *Self-Portrait as a Tehuana* (*Diego in My Thoughts*) (1943) and *Self-Portrait* (1948). She confided to a journalist, however, that "there was a time long ago when I dressed like a boy, with short hair, pants, boots, and a leather vest. But when I went to see Diego, I put on a Tehuana outfit. I have never been in Tehuantepec... but of all the Mexican costumes, it is the one I like the most."

Frida selected her jewelry each day with equal care, especially the rings she wore on the fingers of both hands. She meticulously applied her makeup and painted her fingernails, sometimes purple, green, or orange, according to what best harmonized with the day's outfit. She used to say she dressed *de chango*, like a monkey, for fun, in a silly and playful way. Bertram Wolfe declared that "her appearance would have seemed outlandish were it not for the artistry with which she designed and adorned herself."

Although she never approached the size of her portly mother and stout older sisters, nor even the plumpness of her younger sister, Cristina, Frida worried about maintaining her slender figure. Only a little over five feet two inches tall, she seemed taller because of the heightening effect of her long skirts, accentuated even more by her elegantly long neck and by her upswept hairdo with bows and flowers arranged on top of her head. Her olive skin was covered with a light fuzz; her upper lip had a pronounced moustache, which she made obvious in her self-portraits. The dark, heavy eyebrows that grew together across her forehead she turned into a trademark, representing them in her paintings as a bird, a swallow in flight.

When she was finally finished dressing, she looked "like a princess, like an empress," according to the descriptions most often used by her contemporaries. Scrupulously clean and heavily perfumed, she was as resplendent as a rainbow, ready for one more day.

Frequently she was preparing for sessions with prominent photographers from the United States and Mexico. Since childhood a subject of her father's photographs, she had a true love of the camera and its results. She posed for Edward Weston, Hector García, Imogen Cunningham, Manuel and Lola Alvarez Bravo, Nickolas Muray, Guillermo Zamora, Juan Guzmán, and Bernice Kolko, and an endless stream of photographer-fans who came to admire and record on film her spectacular presence.

Many photographs show Frida, a heavy smoker, holding a lit cigarette. She rarely smiled when in front of a camera; the few

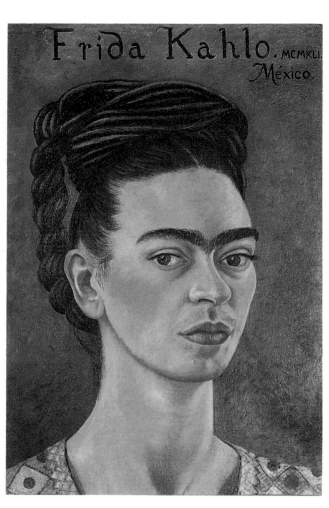

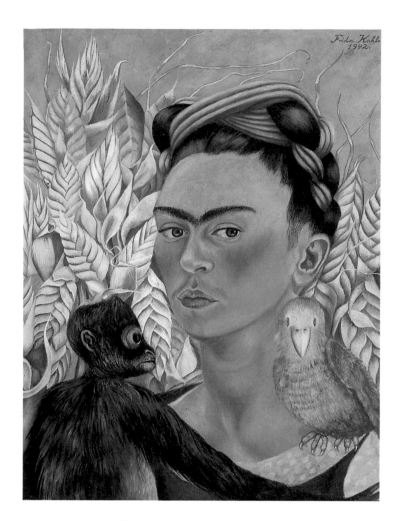

Self-Portrait
1941

Self-Portrait with Monkey and Parrot
1942

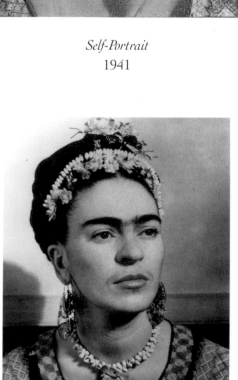

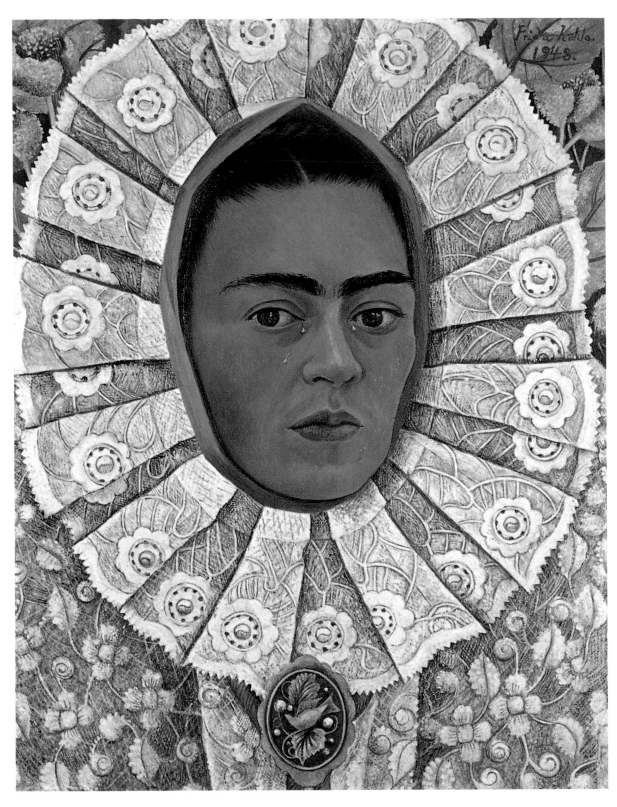

Self-Portrait
1948

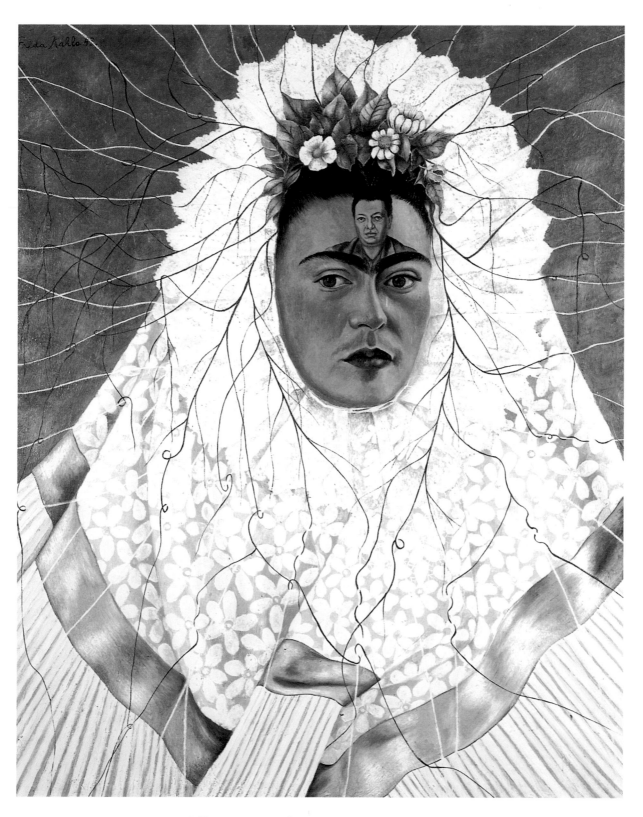

Self-Portrait as a Tehuana (Diego in My Thoughts)
1943

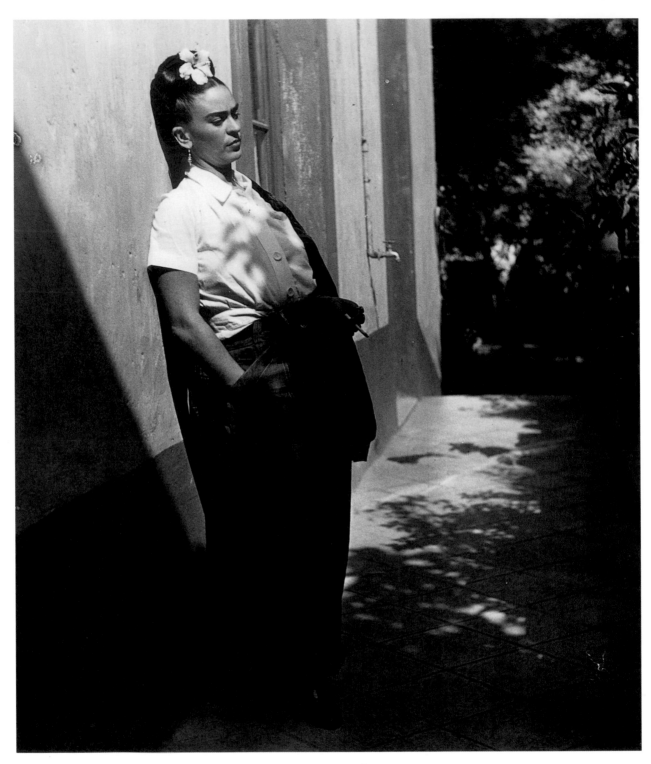

Frida, the Casa Azul, 1941

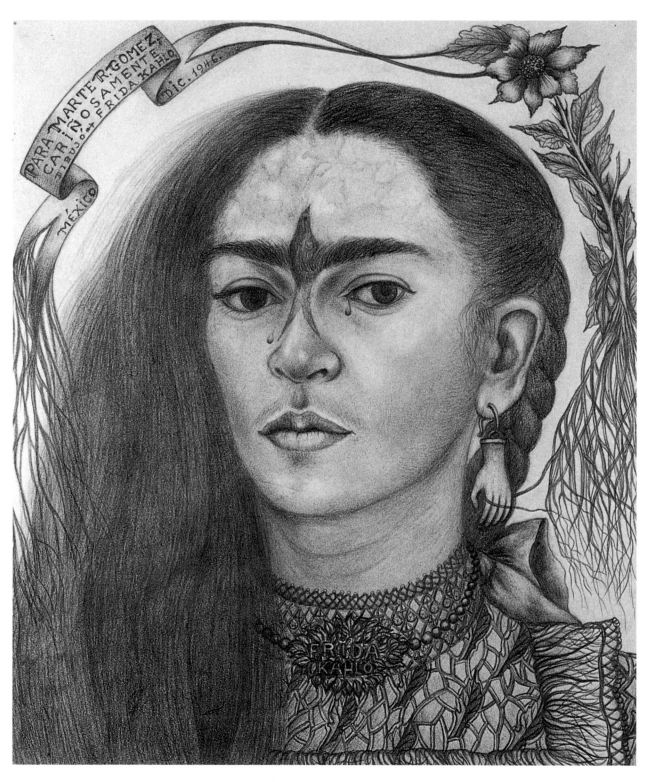

Self-Portrait Dedicated to Marte R. Gómez
1946

photographs that catch her laughing reveal blackened teeth, often self-consciously hidden behind her hand.

For all the grim things in her life, Frida loved gaiety. With her low-pitched, throaty laughter, she enjoyed jokes and anecdotes, wordplay, and scrambling expressions from many languages. Like Diego a bit of a liar if it made a better story and suited her purpose, she was passionate and witty, with a ribald sense of humor; Bertram Wolfe said she used "the richest vocabulary of obscenities I have ever known one of her sex to possess." She frequently made fun of herself, as when she announced it was time for her to go shave. She ridiculed conventionality and everything she thought pompous or foolish, calling stuck-up people *grandes cacas*, big shits.

Along with her own clever phrases, Frida incorporated into her correspondence and speech expressions adopted from others. José Frias, a poet friend of both Riveras, once wryly explained to Frida that "I drink to drown my sorrows but the damn things have learned to swim." Later she used the phrase in one of her letters to refer to her own problems with alcohol.

Frida could apply nicknames so apt that it was impossible for her hapless targets ever to lose them. Diego's driver was called "General Confusion" because everything seemed to go wrong when he was involved, and the houseboy was known as "Manuel the Restless" because of his passive lethargy.

In 1941 Frida's health again deteriorated. Fatigued and losing weight, depressed over her father's recent death, she suffered from asthenia, a loss of strength, and experienced extreme pain, this time in her feet. Doctors were treating her with hormones for irregular menstrual periods and trying to cure a recurrent fungus infection on the fingers of her right hand. Tests, X-rays, and new kinds of corsets to support her back became a routine part of life, with complete bed rest and carefully balanced diets prescribed every so often to get her back on her feet.

In spite of her poor health, the five years following Frida and Diego's second wedding were the most serene of their married life, a time when they seemed to come to terms with one another. Finding pleasure in simply being together and sharing their daily lives, they treated each other with the same outward show of affection as before the divorce—he was her "Sapo-rana," her toad-frog, she his "Chiquita." They seemed satisfied with their decision to continue their marriage.

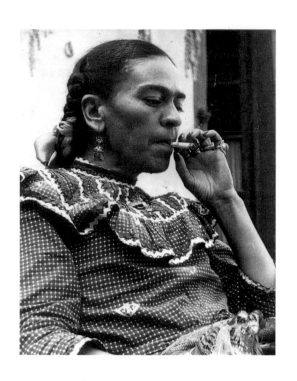

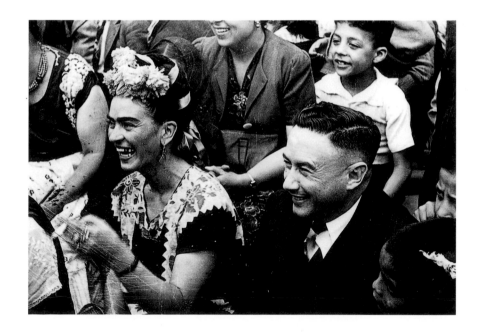

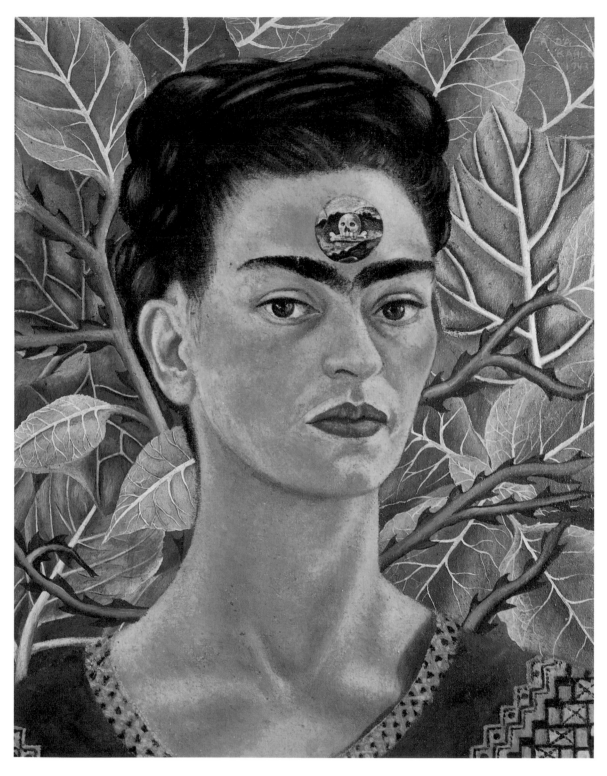

Thinking of Death
1943

According to one version by Diego, however, Frida had made two stipulations governing their reconciliation: she would pay half of the household expenses with earnings from her work as a painter, and they would not resume sexual relations, since for her the mere memory of Diego's infidelities prevented it.

Their friends say neither of these conditions, if they ever existed, was put into practice. Frida contributed the profits from the sale of her paintings, but it was Diego who always paid the majority of their expenses, until her illness not only nullified her contribution but greatly increased the necessary expenditures. Besides the servants for the house, there were nurses, expensive medicines, and drugs, not to mention doctor bills and long periods of hospitalization.

That sexual relations were not a part of Diego and Frida's new marriage is discounted by those close to the pair. Rena Lazo, a young Guatemalan painter who was assisting Diego with a mural, remembers the couple's relationship as warm and normal, full of innumerable expressions of mutual affection. One morning Lazo stopped by the Casa Azul to join Diego for the trip downtown. She asked Chucho, the houseboy, if he knew what time they would leave. His reply was memorable: "I think it will be a while because the Maestro just went to bed with the Señora."

Frida's love for Diego was still the major focus of her life. One of her diary entries gives some sense of her total devotion:

> *Diego...beginning*
> *Diego...builder*
> *Diego...my child*
> *Diego...my sweetheart*
> *Diego...painter*
> *Diego...my lover*
> *Diego...my husband*
> *Diego...my friend*
> *Diego...my mother*
> *Diego...my father*
> *Diego...my son*
> *Diego...I*
> *Diego...universe*
> *Diversity in unity*
> *Why do I call him my Diego?*
> *He never was and he never will be mine.*
> *He belongs to himself.*

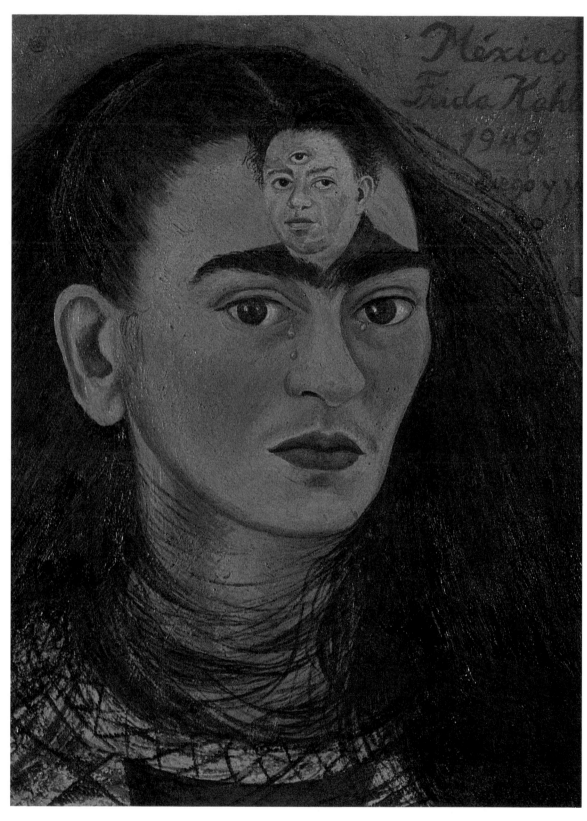

Diego and I
1949

But for all her declared, written, and painted love for Diego, Frida was not above manipulation. Certainly her ailments were genuine, but she dramatized her disabilities to secure his attention, especially when he was involved with another woman. Many of her operations were elective and occurred when she felt threatened by a new love in Diego's life.

Contrary to widespread belief, Frida was not obsessed by frustrated maternity, although it was an idea she encouraged. Two harsh and original pictures painted in 1932, *Henry Ford Hospital* and *My Birth*, support that impression, and viewers are inclined to extend this attitude to all of her work. In fact, Frida's correspondence reveals that she had abortions for unwanted pregnancies before and after the medical crisis in Detroit, and she was perfectly aware that Diego did not want another child. Aside from the risk that a pregnancy posed to her own health, Frida feared possible congenital health problems; she was concerned that her father's epilepsy might be hereditary and that she herself might transmit syphilis, a disease for which she several times asked to be tested, but which only one doctor ever thought she had.

Frida's concept of herself was not that of *la señora respetable*, a traditional married woman, and certainly not a motherly one. When her special art students, the group called the Fridos, once affection-ately brought her a bouquet for Mother's Day, she was not amused; although she was old enough to be their parent, she preferred to consider herself their friend.

What is obvious is that Frida channeled all her maternal feelings into her care of Diego. She spoke to him as if he were a baby, even bathing him and giving him floating toys to play with in the tub. (Perhaps this was to encourage habits of personal cleanliness for which Diego had little inclination.) She found or had made the enormous clothes he required, including underpants of coarse cotton in a shocking pink color which she sometimes embroidered. Each day, to the studio or the scaffolding where he was working, she sent Diego hot meals in a basket coquettishly covered with an embroi-dered cloth and accompanied by love notes. Some days hers was not the only lunch that arrived; other women would also send viands, causing Diego to say amiably to his assistants, "Come, there's enough for all."

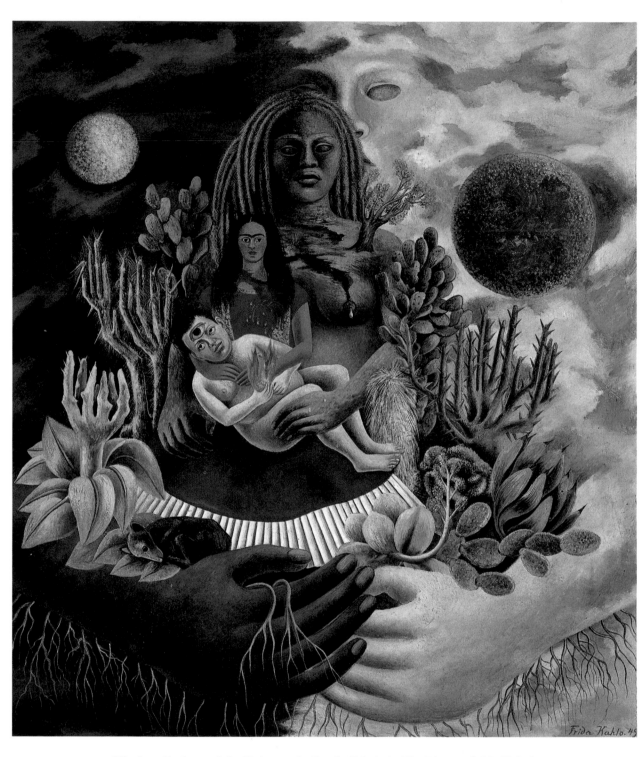

The Love Embrace of the Universe, the Earth (Mexico), Me, Diego, and Mr. Xólotl
1949

Always ideologically in tune with Diego, Frida became involved in his left-wing political activities to promote revolutionary struggles and movements for world peace and political freedom. She spent hours typing Diego's speeches and statements, letters of support for individuals and causes they considered worthy, and petitions for European war refugee assistance. The signatures of both artists were continually requested for statements of protest or political support. Diego at this time was on the outs with the Communist party; he was no longer a member, and he did not agree with some of its positions in the 1940s. His years of contact with Trotsky, his general lack of party discipline, and clashes with others made him an unreliable member, so that as secretary in 1929 he was obliged to read himself out of the Mexican party he had helped to found. Not until the end of his life was he readmitted, and then only after he confessed his previous mistaken beliefs.

Frida remained firm in her socialist convictions and party membership. Interestingly, she almost never showed up at the offices or the meetings of the Mexican Communist party, claiming ill health, although in these same years she attended concerts, frequented popular dance halls, went to movie theaters, and regularly visited her friends. Her Communist friend Concha Michel has conjectured that Frida abandoned active participation in the party because of the secondary roles women played as typists, assistants, or messengers, tasks that would not have interested her.

Although in contact almost daily, by telephone and notes, discussing their health, their friends, and activities, Diego actually spent limited time with Frida. Most of his day was devoted to his painting, but increasingly his time and energy went into planning and constructing a building to house his collection of pre-Hispanic art, the Anahuacalli, to be built on the volcanic lava beds of San Pablo Tepetlapa, near Coyoacán. Frida had purchased a parcel of land, intending it for the house of a Spanish refugee family she had befriended. Diego continued to acquire surrounding parcels until he had a site that suited him. Once construction began, most of the money he earned was used to pay workers and to buy materials.

Kahlo visited the site frequently, and she kept careful account for Diego of all expenditures. She not only controlled the progress of the museum's construction, but supervised all of their

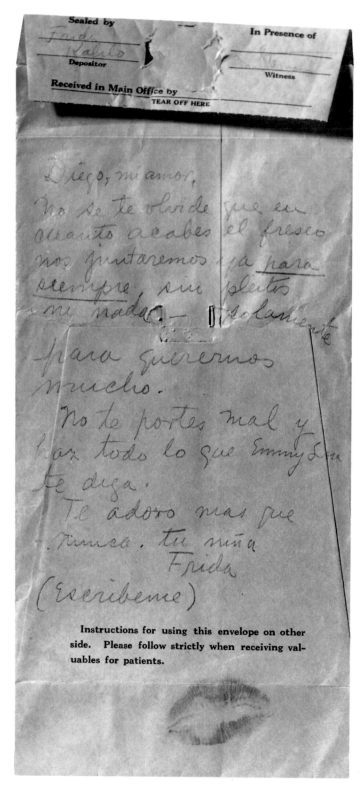

Love note from Frida to Diego, before 1940

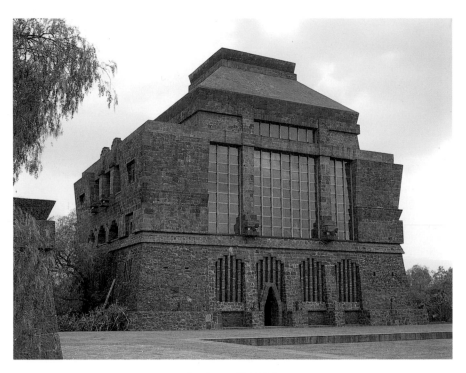

Anahuacalli, 1984

financial affairs, sorted Diego's papers, answered his corre-
spondence, and even kept a file neatly marked "Letters from Diego's
Women." Frida took pleasure in being a good housekeeper and
personally supervised the preparation of the daily meals, especially
those for her husband. Even when finances were tight, she managed
to employ a large staff, at times three or four servants plus their
relatives, and Diego had a chauffeur.

Frida had her own activities as well. At Diego's suggestion,
she started teaching in 1943 at the Ministry of Public Education's
experimental new School of Painting and Sculpture on Esmeralda
Street in the Guerrero district. High-school age students from poor
families in the neighborhood were given free art supplies along with
free instruction in painting and drawing; they also had courses in
French, art history, Mexican art, and general culture. Frida taught
an introductory class in painting at La Esmeralda, as the school
became known, where her colleagues were leading artists and
scholars, including Francisco Zúñiga, María Izquierdo, several
distinguished European émigrés, and Diego.

Frida taught informally, with respect for each student. On the
first day she asked the students what they wanted to paint, and they
immediately asked her to pose. One student, Guillermo Monroy, still
remembers the vivid impression she made: "Frida was there in front
of us, amazingly still. Her hands, placed one on top of the other, were

Frida and Los Fridos, c. 1943. From left: Fanny Rabel, Frida, Arturo Estrada, and Arturo García Bustos.

elegant and bedecked with rings. Her beautifully manicured fingernails were long and lacquered with bright red polish. Her silky black hair was criss-crossed on top of her head in meticulous braids, beautifully decorated in the center with a tiny bunch of gaudy magenta bougainvillaea. Her filigree earrings were two small suns made of gold. Smooth skin, firm and cool. Dark, restless eyes seeing beyond earth and sky, black eyebrows joining to form the delicate wings of a bird. The freshest of smiles flowering on her red lips. At her throat she wore a necklace of fine intertwined gold chains with a charming and beautifully worked heart-shaped pendant encircled by a ring of stars. Her blouse was a traditional native huipil embroidered with red flowers on a yellow ground set off by a front panel of black, her full skirt decorated with small geometric shapes of gold and magenta. Resting softly on her shoulders was an elegant black rebozo, delicately fringed and sprinkled with tiny bunches of shamrocks."

Frida directed long conversations that stimulated her students' curiosity and imagination; she took them to off-beat places like Huejotzingo in carnival season, the nearby cities of Texcoco and Puebla, and the pyramids of Teotihuacán, "so they would appreciate what magnificent builders their great ancestors were." She wanted to

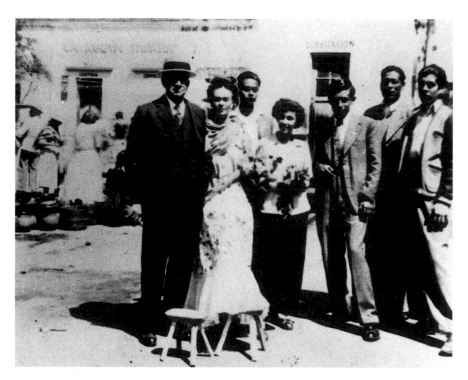

Alberto Veraza, Frida, Guillermo Monroy, Fanny Rabel, Arturo García Bustos, the
chauffeur, and Arturo Estrada, Texcoco, c. 1944

better their appreciation of the arts of Mexico, especially its folk art,
but also of modern murals with their clear social messages.

A few months after she began teaching, it became obvious
that Frida's health would prevent her from traveling to La Esmeralda.
Frida continued the course in her home; each day the students
commuted to Coyoacán. At first, the entire group arrived to paint in
the garden of the Casa Azul, but finally there remained only four
students, Guillermo Monroy, Arturo García Bustos, Arturo
"Guero" Estrada, and Fanny Rabel. The group became known as
the Fridos.

The students adapted well to Frida's unorthodox system of
instruction: creative freedom closely linked with self-discipline, a
method that required neither the teacher's constant presence at the
student's side nor the taking of a paintbrush from the student's hand
to correct his or her work. Frida left her students to follow their own
paths, respecting their ideas and their work and treating them like
mature adults.

Monroy recalls that Frida suggested that they go out in the
street, "to get acquainted with life so we could understand it better
and be able to paint it. We all went to the markets, the factories, the
countryside, we mixed with the people....Frida told us that direct

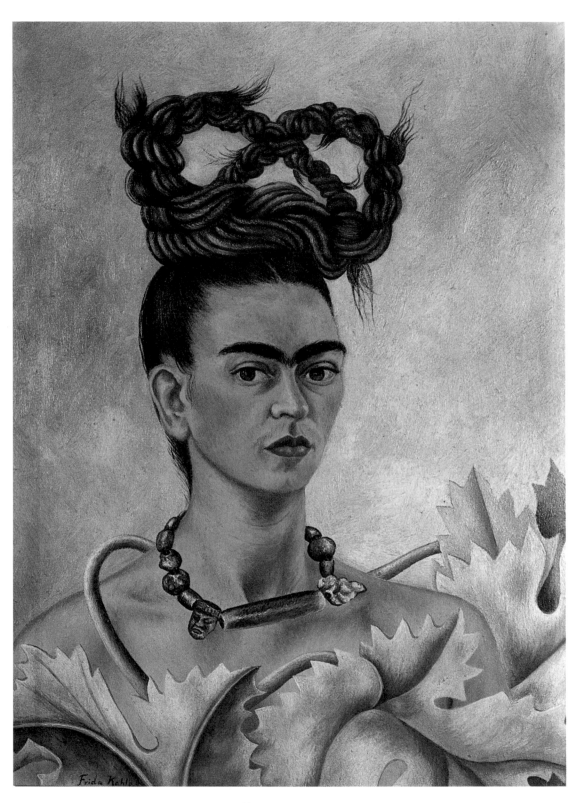

Self-Portrait with Braid
1941

contact with life and participation in it, not as mere spectators but as socially active citizens, would open new artistic horizons and greatly enrich our aesthetic and human sensitivity."

Frida also urged them to go out and visit the sites where the great muralists were working. These artists were still very active in the early 1940s. Rivera was painting a mural in the Hotel Reforma's nightclub, another about medical history in the recently inaugurated National Institute of Cardiology, and a new series of murals in the National Palace. From 1942 to 1944 Orozco was working on the dome and choir walls of the historic old Church of Jesus the Nazarene, and in 1944 Siqueiros was creating his *Cuauhtemoc against the Myth* in the Center for Modern Realist Art.

Frida was anxious to give her students a chance to get started in mural art themselves. In the middle of 1943 she obtained permission for her students to decorate the wall of a tavern, the Pulquería La Rosita, located a short distance from the Casa Azul. Two years later, Frida arranged a second mural commission for her students: the walls of a laundry facility, one of the public works of the Lázaro Cárdenas administration.

At Frida's urging, her students participated in exhibitions, where the political content of their work sometimes caused them trouble with the public, but never with Diego and Frida. The couple was also supportive when the Fridos joined other students to found the Revolutionary Young Artists, a group that organized exhibitions in public parks and gardens so that their artwork could be seen by workers and the poor.

Notwithstanding the physical and spiritual closeness of Frida and her students over the years, not one of them claims to have ever seen her paint. She brought out her canvases from the studio when the class had critiques, or she would invite the students to come inside and see her work in progress. But when she painted, she worked in isolation.

A visit with Frida was becoming obligatory for every important person traveling through Mexico City. Through her home passed the Rockefellers, Edward G. Robinson, Josephine Baker, poet Gabriela Mistral, the presidents of various countries, many ambassadors, and other luminaries. Frida enjoyed holding court. In spite of

her poor health, she was at the height of her physical beauty and had polished to perfection the image she wanted to project. The impact she produced was truly memorable, and she knew it.

Except for the last years of her life, the Casa Azul was a happy gathering place where the artist frequently organized social get-togethers for her friends. There was an endless parade of notable Mexican figures, film star Dolores del Río, writers Salvador Novo, Carlos Pellicer, and Pita Amor, movie actress María Félix and her husband, the famous singer Jorge Negrete, and the leading painters. They came to enjoy an excellent meal and Frida's invincible good humor. Each year she organized *posadas*, the typical Christmas season parties, with plentiful confetti, piñatas, and fireworks.

Most of Frida's relatives had grown distant after her marriage to Diego. Her aunts, as religious as her mother, did not permit their children to visit the Casa Azul: the couple living there was not married in the eyes of the church, and they belonged to the Communist party. Frida's cousins laughingly recall that some of the Calderón aunts sprinkled holy water on the sidewalks as they passed the house, especially in the years when Trotsky lived there.

But Frida was once again close to her younger sister, Cristina, who came with her children, Isolda and Antonio, to visit several times a week. The children of other friends remember Frida as a "beautiful lady who smelled good, covered with fuzz like a peach," someone who let them play with all the marvelous contents of her handbag and whose use of bad words made them laugh.

In about 1944, Frida began a diary, writing in a red leather-bound book. Written in a highly creative and imaginative style, and illustrated with drawings in pencil, colored inks, and watercolors, the diary at first recorded autobiographical information and selected anecdotes but became, with the passage of time, a summation of emotional, sometimes hysterical, outpourings. It was not unusual for Frida to show the diary to friends; she sometimes even tore out pages to give to them.

All the while, at her own slow pace, Frida painted. By the mid-1940s, she was as well known abroad as in Mexico for her art, and she was frequently invited to participate in group shows. She could sell whatever she was currently painting; sometimes incomplete pictures were purchased right off the easel. This has

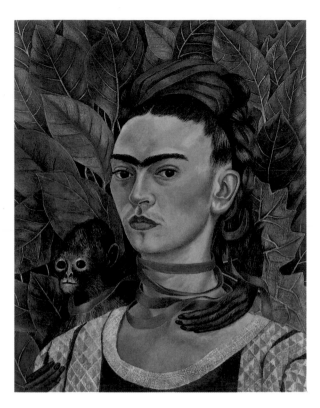

Self-Portrait with Monkey
1940

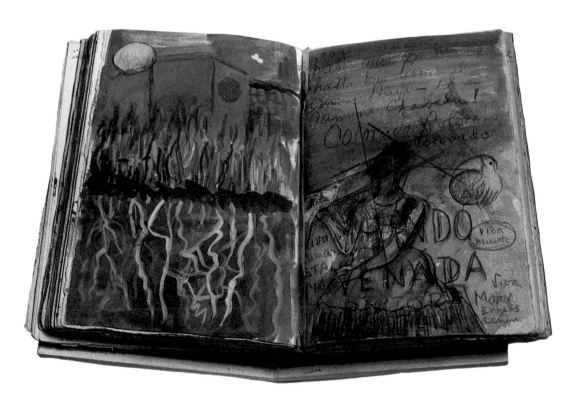

A page from Frida's diary

complicated locating her work today, for in many cases no trace remains, not even a photograph and no more of a written record than "self-portrait" and a date. It also meant she never at one time had a large number of paintings for exhibition purposes.

At about this time Frida created several suggestive and uneasy still lifes of fruits and vegetables, sometimes including personally significant objects. A round still life was done for the dining room of the Mexican presidential residence, Los Pinos, but was later returned, perhaps because its fruits were too voluptuously graphic. She also painted still lifes of moist, audacious flowers with pistils of phallic form that pay homage to sensuality as a manifestation of life.

But most of her work was portraiture, of herself, her friends, and relatives. Some were commissioned, many for her friend and major patron, the engineer and diplomat Eduardo Morillo Safa. He ordered pictures of himself, his wife, son, daughters, and a very moving portrait of his mother, Doña Rosita Morillo Safa.

Certainly Frida's single most frequent theme was the obsessive self-portrait, in which she appears alone or with her pets or other meaningful articles. When asked, as she frequently was, why she painted herself so often, she replied, "Porque estoy muy sola" (because I am all alone). Some theorize that she painted herself to ensure she would be remembered. Alejandro Gómez Arias suggests that Frida's continual portrait painting was "a recourse, the ultimate means to survive, to endure, to conquer death."

In letters she sent to the most casual friends as well as to those she loved most profoundly, in her youth and her maturity, Frida continually used the phrase, "Don't forget me!" In later years, she began distributing photographs of herself in great quantities, perhaps another permanent and tangible means of safeguarding her place in people's memories.

In 1945, after reading Sigmund Freud's *Moses and Monotheism*, given to her by a friend and patron, José Domingo Lavin, Frida painted a large oil, *Moses*. The result, done over three months, has the pictorial complexity of a mural design and is unlike her other work. At the center of the composition Moses floats on the river in a basket, looking out with a third eye in his forehead, the eye of knowledge. Some of Frida's recurring symbols appear—a snail, rainfall of milk, skeletons—along with great figures from history:

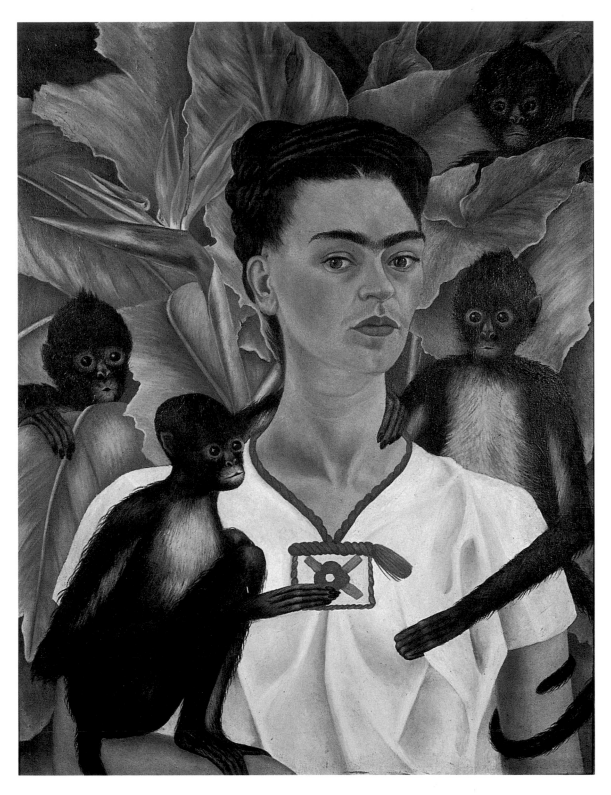

Self-Portrait with Monkeys
1943

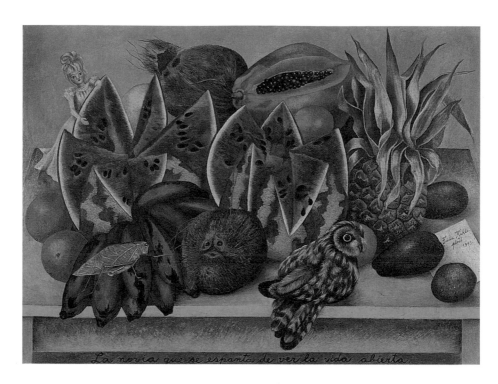

The Bride Frightened at Seeing Life Opened
1943

Flower of Life
1944

The Chick
1945

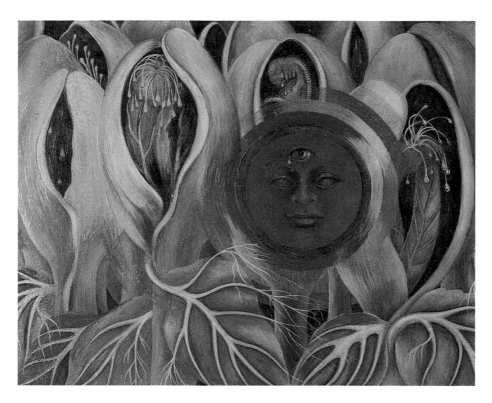

Sun and Life
1947

Magnolias
1945

Portrait of Mariana Morillo Safa
1944

Portrait of Doña Rosita Morillo Safa
1944

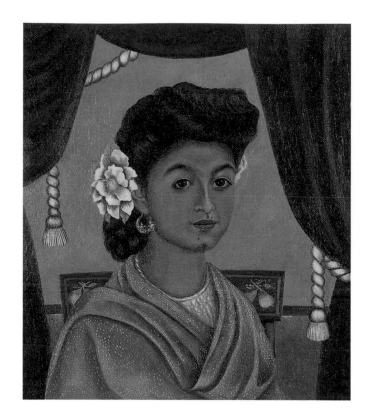

Portrait of Lupita Morillo Safa
1944

Portrait of Natasha Gelman
1943

Portrait of Marte R. Gómez
1944

Christ, Gandhi, Buddha, Marx, Stalin, Nefertiti, and Napoleon. There are also Egyptian, Greek, and Aztec deities and crowds of common people. "What I wanted to express very clearly and intensely," Frida declared, "was that the reason these people had to invent or imagine heroes and gods is pure fear. Fear of life and fear of death."

Although largely self-taught, and considered by many to be a naive painter, Frida was actually very sophisticated. Intelligent, well-read, and well-informed, she was acquainted with the traditional schools of painting. More important, she recognized the vanguard of Mexican and foreign art not only through her travels but through direct contact with the artists. Direct influences show up in some cases, as in *Magnolias* (1945), reminiscent of the work of Georgia O'Keeffe, or in *Four Inhabitants of Mexico City* (1938), recalling de Chirico. Her earliest works showed an acquaintance with art books; in her first self-portrait for Gómez Arias, she described herself as "your Botticelli," and in letters to him she expressed interest in Modigliani and Piero della Francesca. Her use of suffocating background vegetation is similar to that of Henri Rousseau, the small figures in *What the Water Gave Me* (1938) like something out of Hieronymus Bosch, and the written legends in others like those of the Mexican painter Hermenegildo Bustos.

But Frida was also the product of a bold and brilliant generation that looked back with devotion to its Mexican roots and valued the reality it found there, uncontaminated by foreign influences. She admitted to having a great admiration for her husband's work, as well as that of José Guadalupe Posada, José María Velasco, and Gerardo Murillo (Dr. Atl), and she found great beauty in the highly developed pre-Conquest indigenous arts.

Frida and Diego possessed several hundred Mexican ex-votos. These religious paintings, done by anonymous artists, traditionally are donated to churches as offerings to Jesus Christ, the Virgin, or a favorite saint in acknowledgment of divine intervention in times of severe trouble or illness. Generally painted on small pieces of metal, they carry short verbal descriptions of the events depicted. This format inspired Kahlo to combine text and imagery in many of her works and to paint scenes in commemoration of significant relationships and occasions. In *Self-Portrait with Portrait of Dr. Juan Farill* (1951), the image of the doctor substitutes for the

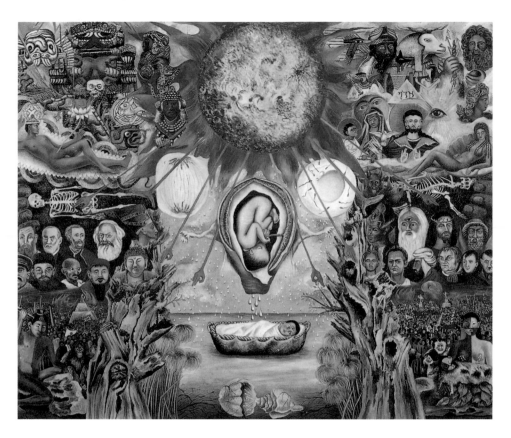

Moses
1945

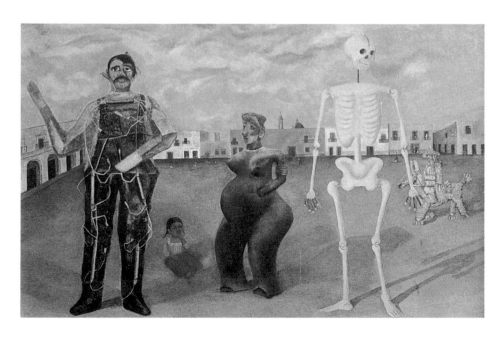

Four Inhabitants of Mexico City
1938

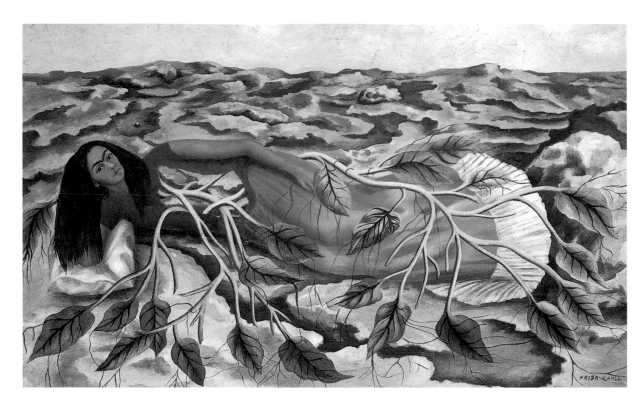

Roots (The Pedregal)
1943

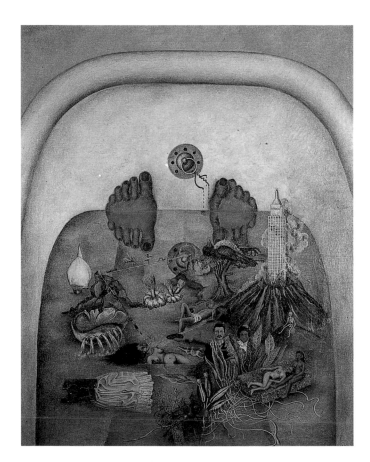

What the Water Gave Me
1938

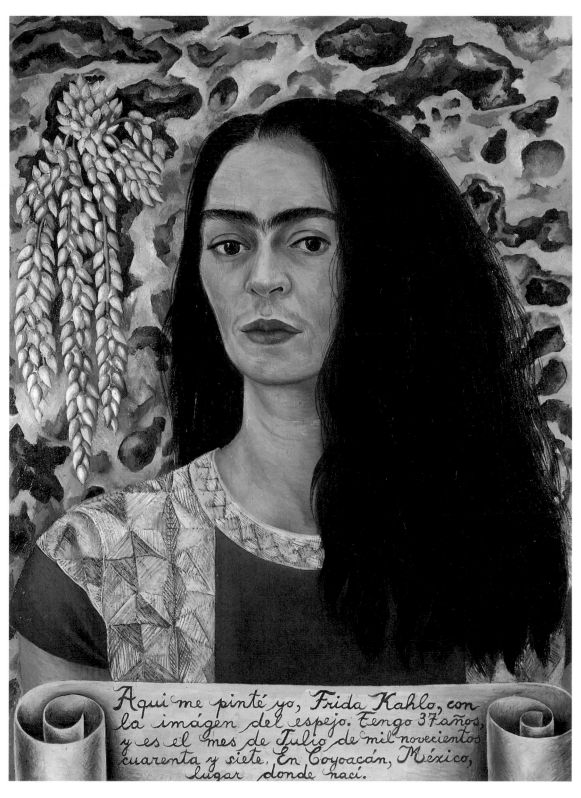

Aqui me pinté yo, Frida Kahlo, con
la imágen del espejo. Tengo 37 años,
y es el mes de Julio de mil novecientos
cuarenta y siete. En Coyoacán, México,
lugar donde nací.

Self-Portrait with Unbound Hair
1947

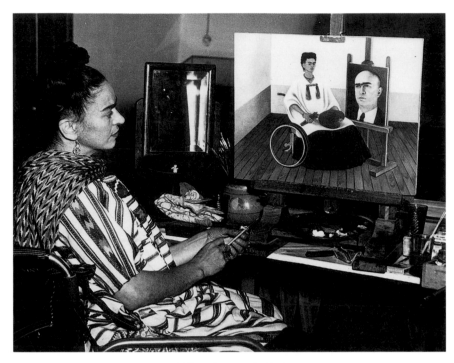

Frida at her easel, 1951

miracle-working saint, and Frida, the invalid, sits in a wheelchair, painting with her own blood, using her obliging heart as a palette.

Frida was claimed early on by Breton and the Surrealists as one of their own, and for a time she did not seem to mind being caught up and identified with the chic vanguard movement. But later, she declared herself not one of them, and most today would agree. "I never painted dreams," she said. "I painted my own reality."

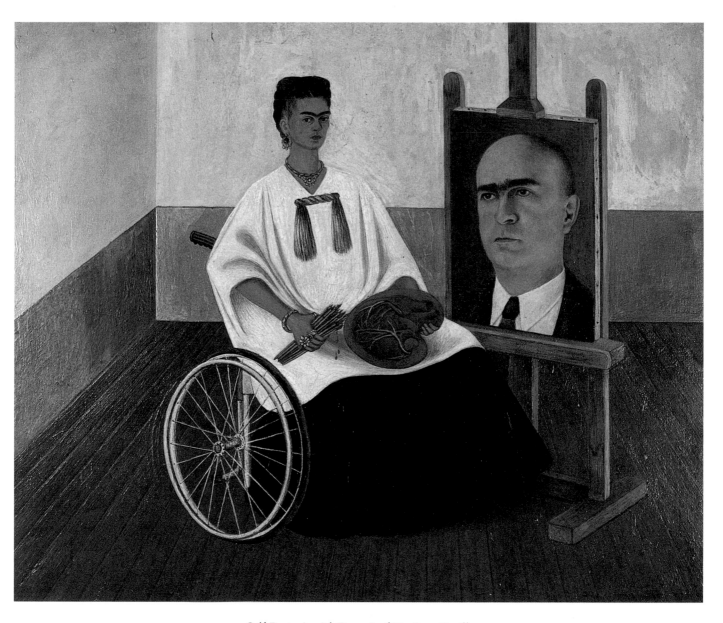

Self-Portrait with Portrait of Dr. Juan Farill
1951

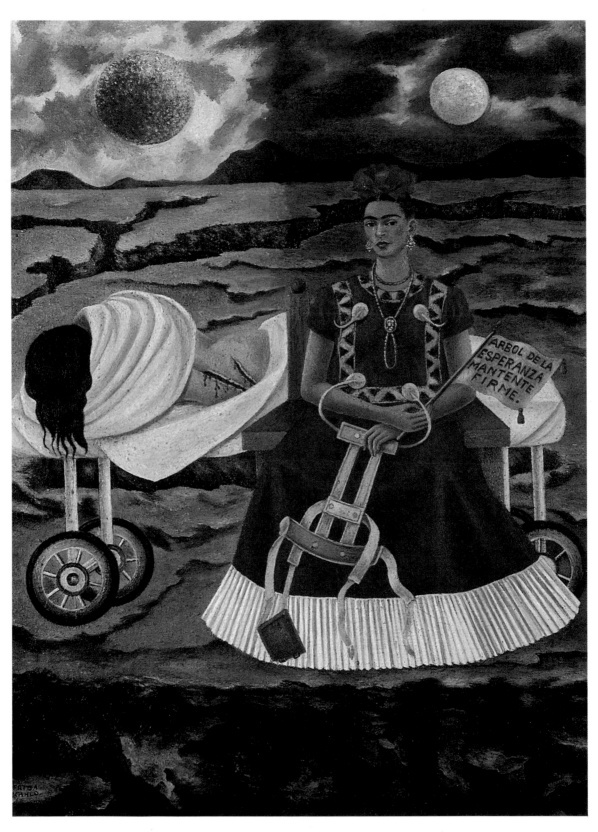

Tree of Hope, Stand Fast
1946

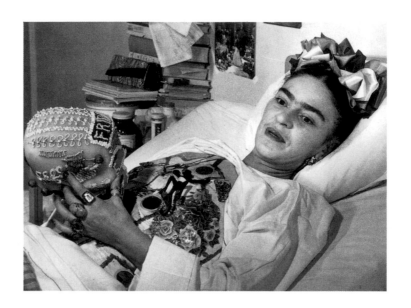

Tree of Hope

In 1946 Frida painted *Tree of Hope, Stand Fast*, titled with a line from a favorite song and a phrase she used often. Frida lies on a gurney, a sheet pulled back to reveal bloody incisions in her back. Another Frida sits on a chair, costumed and holding a brace and a banner proclaiming "Arbol de la esperanza, mantente firme." The picture refers to her most recent operation: Frida had been to New York in June for surgery to fuse four vertebrae with a metal rod and a piece of bone extracted from her pelvis.

Before the surgery, Frida had presented another picture, *The Wounded Deer* (*The Little Deer*) (1946), to her good friend Arcady Boytler. A beautiful animal, with the body of a deer and Frida's head, has been impaled by arrows. The creature faces her fate with equanimity, much as Frida did when she agreed to the operation. She was optimistic about the prospect of relief from the constant pain she endured, but as time went on, it became clear that this point marked the beginning of the end.

For some time prior to the U.S. trip, Frida had been suffering increasing fatigue, weight loss, anemia, and pain in her right leg and back. A fungus growth had reappeared on her right hand, and she was in a nervous and despondent state. Doctors diagnosed and treated her for a variety of ailments, prescribing complete rest, diets, medicines, injections, and steel and plaster corsets. The corsets offered some relief but did not stop the pain.

After months of confinement, she finally flew to New York with her sister Cristina for the operation. Although again bedridden for several months, Frida seemed to recover well. But once back in Mexico, her condition did not improve. Frida's mood swung from euphoria to deep depression, and she was subject to fits of paranoia. At times violent, she would throw things, even at Diego, and hit people with her cane. She was drinking, and her constant pain required daily doses of Demerol and other drugs on which she became hideously dependent in her last years. As her health deteriorated, Frida became absorbed in the details of her case, perhaps morbidly so, discussing her ailments at length with her physicians. Her doctors now included a psychiatrist. (Frida was the first woman in Mexico to undergo psychoanalysis.)

Medical expenses and construction costs of the Anahuacalli museum were exacerbating Diego and Frida's already strained financial condition. They often painted with sales in mind, hoping to generate quick income. Diego once took watercolors around to sell to friends to pay the electric bill. Occasionally when in need, Frida would send a painting to a friend unasked, with a bill for ten thousand pesos, her going price. (Delores del Río once sent back an unsolicited work; Frida was furious and ended the friendship.) Now under a heavier burden than ever before, Diego would sometimes paint two watercolors a day.

Largely housebound, Frida was spending long hours alone. Diego was seeing the beautiful film star María Félix, and the newspapers talked of a possible divorce. But the marriage held, and their relationship, although pervaded by illness and infidelities, was not without sudden displays of loving affection. Salvador Novo wrote, "At night when he stayed to take care of her, Diego closed the doors one by one and slept in the room next to hers.... The evenings that he spent in Coyoacán he tried to amuse her. He danced and sang songs in French, English, Russian, and native Indian languages.... Frida could watch from her bed, Diego all the while forgetting that it was three o'clock in the morning, because when he worked, or when he played, he completely forgot the time." Adelina Zendejas recalls visiting Frida at the hospital late one evening to find Diego with a tambourine, dancing around her bed like an enormous bear.

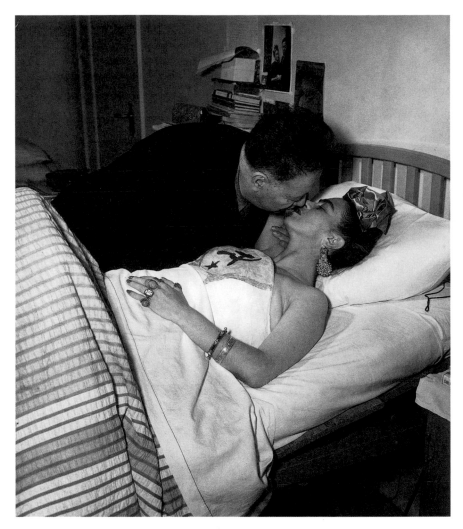

Diego and Frida, 1950

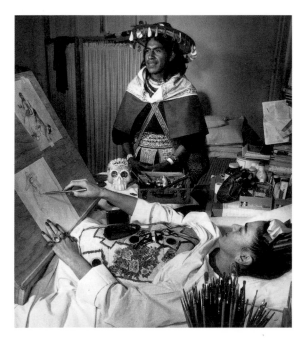

Frida sketching a Huichol Indian, 1950

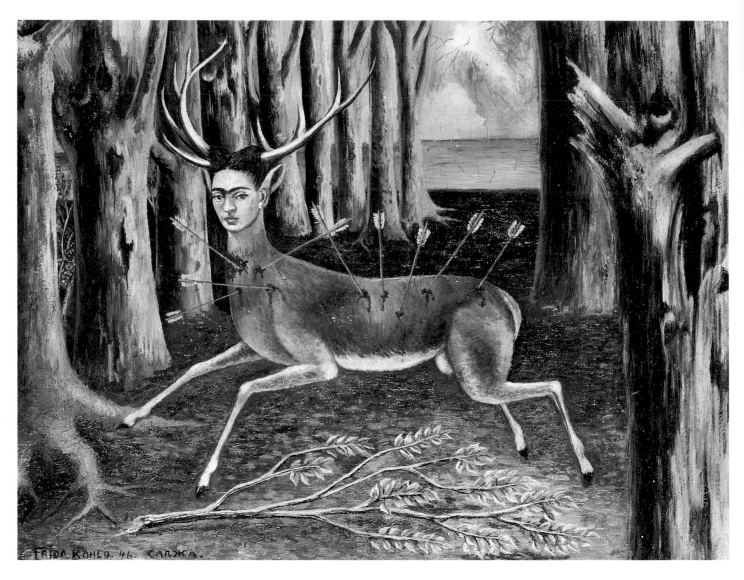

The Wounded Deer (The Little Deer)
1946

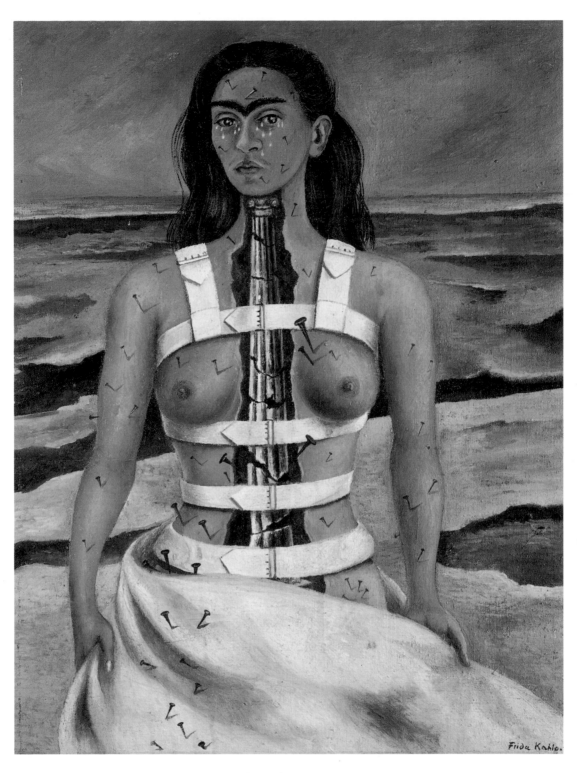

The Broken Column
1944

By 1950 Dr. Juan Farill decided Frida should undergo another bone graft, one which proved disastrous. The implanted bone caused a severe infection, and Frida spent the next nine months in the hospital. For a time Diego took a room next to hers. Throughout the day, her room became a meeting place for doctors and for friends who brought films, books, decorated candy skulls, and all kinds of gifts. She continued to paint although confined to her bed. Diego even sent a fully costumed Huichol Indian to pose for her. In the midst of the visitors, the attention, the support of her sisters and the drugs that sustained her *espiritu contento*, as she called it, she went from treatment to treatment, hoping to relieve her constant pain.

A letter from her sister Matilde to Frida's old friend Dr. Eloesser catalogs the grim details of Frida's condition. On removing one of her orthopedic corsets, the medical staff found a purulent abscess, which again sent her to the operating room, how the smell of "a dead dog" emanated from another wound that would not heal, and how the blackened tips of the toes of Frida's infected foot fell off spontaneously.

Matilde also told Eloesser that "Diego had behaved himself very well this time," and therefore Frida was calm, grasping at the edges of hope, still dreaming that each operation would be the last.

Despite these trials, there were attempts to maintain the old ways of gaiety, excitement, and drama. In December 1950, when Frida was home again, she and Diego held a big fiesta to celebrate the tenth anniversary of their second marriage. Frida appeared as a bride with a veil and a crown. Diego was elegantly garbed in a theatrical cape and broad-brimmed hat. Her brother-in-law "married" them in a mock ceremony, asking if anyone knew of any obstacle to the wedding; at this point Diego's daughter by Lupe Marín, Ruth Rivera, then tall and husky and in her twenties, to everyone's amusement entered dressed like a baby and carrying a big pacifier, shouting "Daddy! Daddy!"

Although she became gradually distanced from many old friends, Frida in her last years enjoyed a close group of special visitors. Cristina and her children continued to visit, as well as Frida's older sisters. From her bed upstairs in the Casa Azul, she held a mini-salon where she reminisced about long-ago adventures such as going with Picasso to the Deux Magots. Poet Carlos Pellicer and art

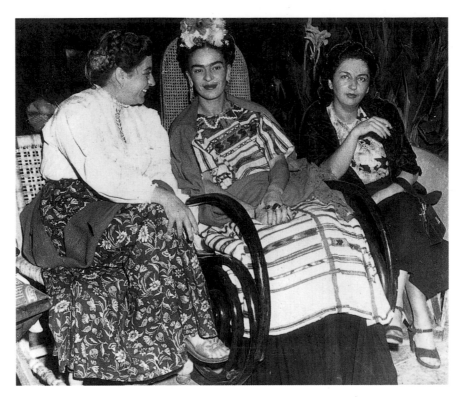

Aurora Reyes, Frida, and Cristina Kahlo, c. 1950

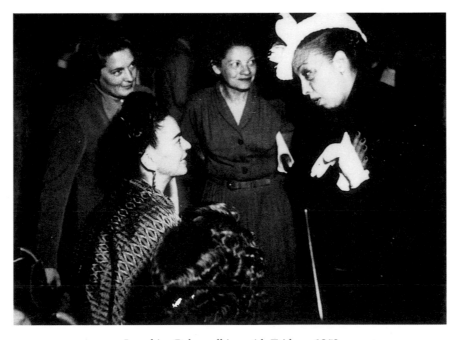

Josephine Baker talking with Frida, c. 1952

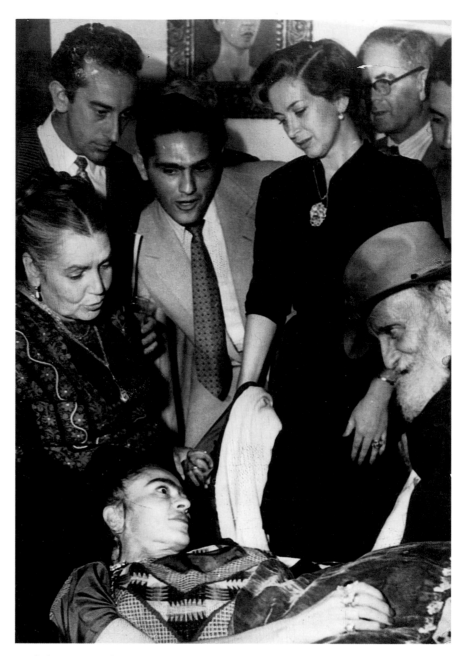

Frida being greeted by Dr. Atl (far right) at the opening of her exhibition at Galería de Arte Contemporáneo, April 13, 1953

critic Antonio Rodríguez were frequent guests. Teresa Proenza, Diego's secretary until his death, and Elena Vásquez Gómez, who worked at the Foreign Ministry, came often; their names, with those of María Félix, Diego, and painter Irene Bohus, were painted in red letters around Frida's bedroom wall as a tribute to their special friendship.

In 1953 preparations were started for a retrospective of Frida's art at the National Institute of Fine Arts, but events moved so slowly that Diego was afraid Frida would not live to see it. Their friend Lola Alvarez Bravo offered to have the show in April at her

Light (Fruit of Life)
c. 1954

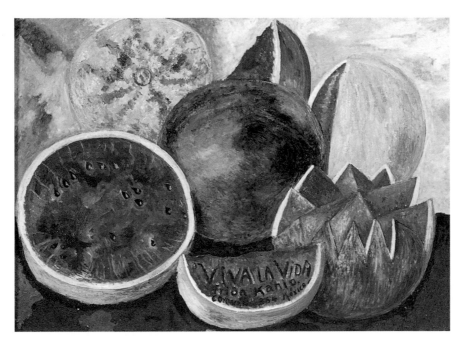

Long Live Life
1954

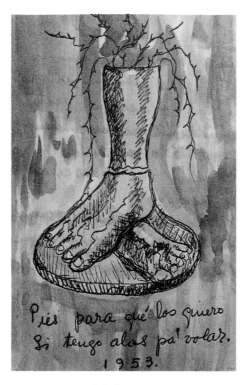

Frida's diary, 1953

large Galería de Arte Contemporáneo. It would be Frida's first one-person exhibition in her own country, and only her second anywhere. Diego personally supervised the installation, and Frida made the invitations. It was a great lift to her spirits, but to the last minute no one knew if Frida would be well enough to attend.

With her usual flair, however, Frida arrived at the exhibition's opening by ambulance with a motorcycle escort. Too ill to stand, she lay in the center of the crowded room in her canopied bed, which had been brought for the occasion from the Casa Azul and remained as an integral part of the exhibition. From her bed she greeted each of her guests as they passed through an informal receiving line. It was a macabre, theatrical event. To *Time* magazine reporters she declared, "I am not sick. I am broken. But I am happy to be alive as long as I can paint."

The next month Frida was hospitalized once more, and by July doctors decided it was necessary to amputate her right leg below the knee because of the gangrenous condition of her foot. It was a terrible blow. She spent three months in the hospital, dispirited when alone, but able to make humorous remarks to visiting friends about the unimportance of her leg. In her diary she wrote the poignant phrase, "Pies para qué los quiero, si tengo alas pa' volar?" (Feet, why do I want them if I have wings to fly?).

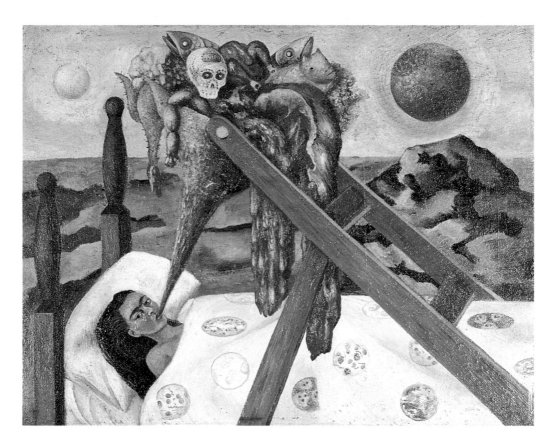

Without Hope
1945

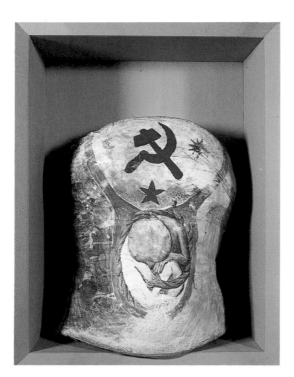

One of Frida's plaster corsets, which she decorated
with a hammer and sickle, c. 1950

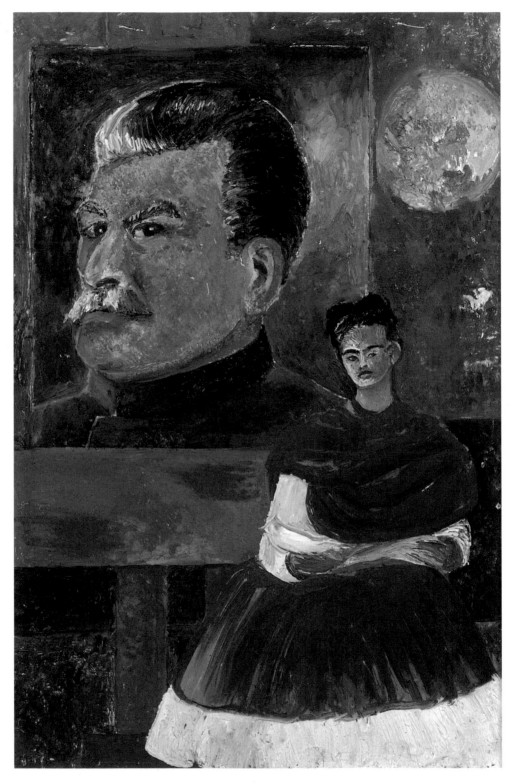

Frida and Stalin
c. 1954

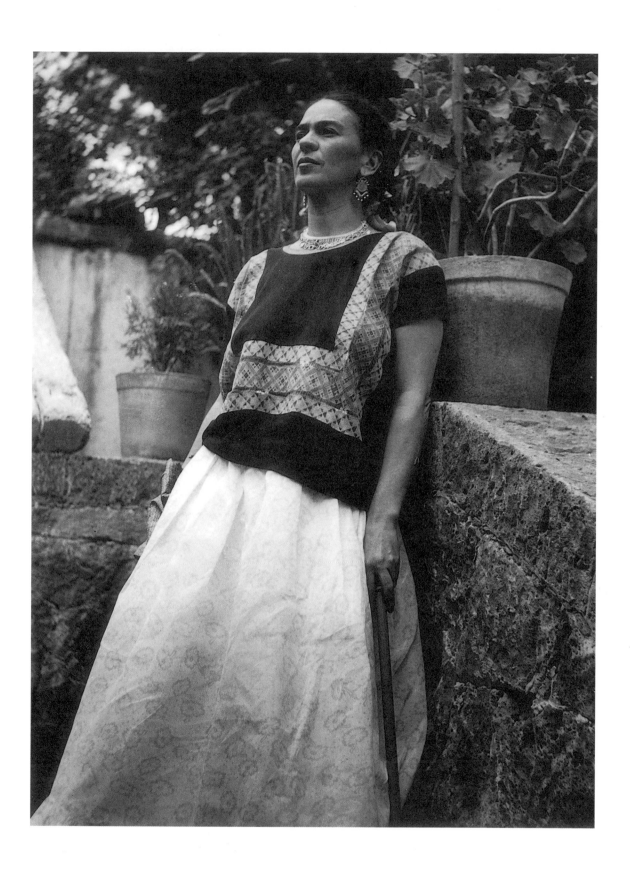

Drug-ridden, alcoholic, and smoking heavily, Frida painted very little in 1953 but a few still lifes of fruit, done with an unsteady hand and heavy paint. She was fitted with an artificial leg but disliked wearing it, preferring to use a wheelchair or crutches to get around. "They amputated my leg six months ago," she wrote in her diary in February 1954. "They have given me centuries of torture and at moments I almost lost my reason. I keep on wanting to kill myself. Diego is what keeps me from it through my vain idea that he would miss me. He has told me that and I believe it. But never in my life have I suffered more. I will wait a while...."

One of Frida's last paintings is a still life of ripe, red watermelons, inscribed with the words "Viva la vida," long live life. Even so, she went to the hospital twice, in April and May, possibly for attempted suicide. On July 2, pale and weak, she made her last public appearance at a demonstration protesting C.I.A. intervention in the overthrow of leftist President Jacobo Arbenz of Guatemala. Without makeup or her usual colorful outfit, her hair covered by a wrinkled scarf tied under her chin, she rode at Diego's side in her wheelchair, holding up a placard declaring "Por la paz," for peace.

Marching in the rain with the crowds was a strong gesture of support for Diego and a political cause, but one that exacted a final toll on her frail health. She returned home exhausted and soon developed bronchial pneumonia. During the next days she felt tired and dispirited. On her forty-seventh birthday, July 6, a few friends came to celebrate, waiting for her to come out of her drugged stupor so they could see her dressed up, vivacious and happy, for what proved to be the last time. Frida died seven days later from a pulmonary embolism, according to the death certificate signed by her psychiatrist, Ramón Parres. Her death might actually have been by suicide or an accidental overdose of drugs and alcohol, but no postmortem was performed.

The last entry in her diary is a sketch of a black angel with the words, "Espero alegre la salida—y espero no volver jamás. Frida" (I hope for a happy exit and I hope never to come back).

Placed in a coffin, her hair dressed, her hands bejeweled, Frida's body was taken through rainy streets to lie in state at a government building, the Palace of Fine Arts. The director, Andrés Iduarte, an old friend from the Prepa, granted this tribute with the understanding that Diego would not turn it into a leftist political

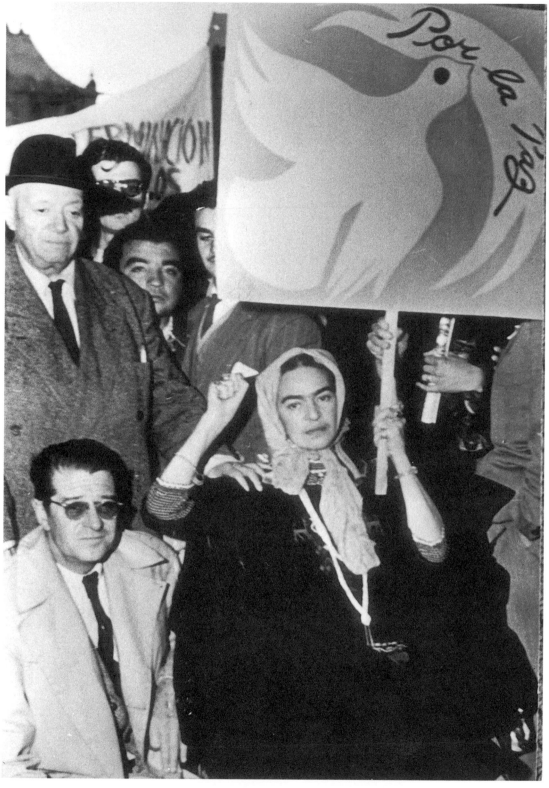

Frida's last public appearance, on July 2, 1954, at a rally protesting C.I.A. involvement in Guatemala. Diego is behind her, Juan O'Gorman to her right.

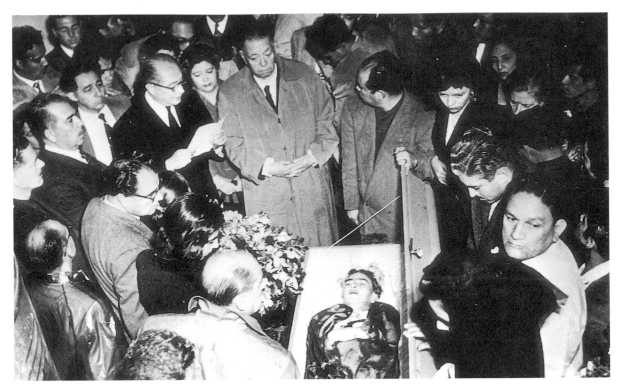

Frida's body surrounded by family and mourners, Palace of Fine Arts

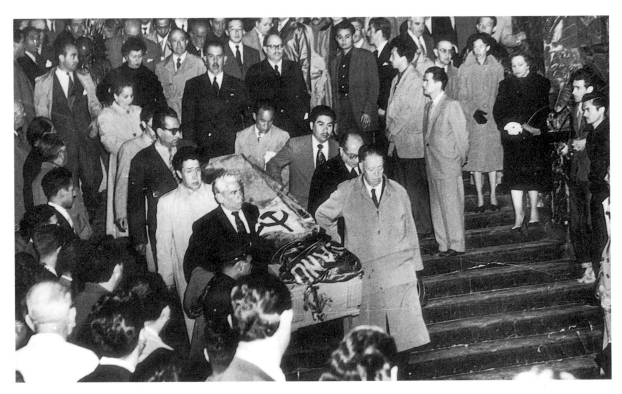

Frida's casket being carried from the Palace of Fine Arts

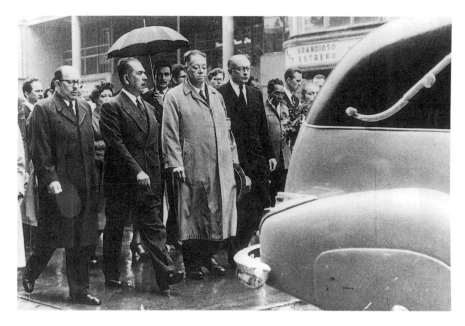

Frida's funeral procession, July 14, 1954

event. Diego agreed, but also assented when one of the Fridos, Arturo García Bustos, placed a red Communist flag with hammer and sickle over her bier, causing days of turmoil that Frida would have loved. Diego's refusal to remove the flag helped him gain his long-sought readmission to the Communist party some months later, but Iduarte lost his job.

A great crowd came to pay respect to Frida for the last time and, under lightly drizzling rain, walked behind the hearse that carried her body to the venerable Panteón Civil de Dolores for cremation. This was her choice: having spent so much of her life flat on her back, she had always said emphatically that she did not want to be buried lying down.

Director Iduarte spoke, Carlos Pellicer read his moving sonnets, and Adelina Zendejas, a friend since Prepa days, remembered Frida with a few words. With Diego and her sisters stood David Alfaro Siqueiros, Juan O'Gorman, Miguel Covarrubias, and a host of other friends. Her body was laid out on a straw petate and rolled into the ovens. As the flames consumed her remains, Frida's friends and relatives sang songs—the Mexican national hymn, the "Internacional," "Los Cuatro Generales," "La Adelita," "Adiós mi Chaparrita," and "Benjamín el Minero." Afterward, Diego gathered her ashes into a silk scarf to take them home.

In July 1958, four years to the month after her death, the Casa Azul was opened to the public as a museum. The tall windows facing the street have been bricked in, but the walls are still painted blue, and Judas figures still loom at the entry. One can walk through the thick-walled rooms and gaze at the cupboard filled with toys, the retablos hung on the stairway wall, the painted pages of an open diary. Upstairs, an unfinished portrait of Stalin waits on the studio easel. From the hallway through an open door there is a view down to the garden, where doves still nest in pottery niches set into the walls. On the canopied bed sits a decorated plaster corset, mocking testimony to pain transcended. The ashes of Frida Kahlo rest nearby in an ancient pre-Conquest urn. Although she is gone, she lives on through her paintings, her story, and the silence of the Casa Azul.

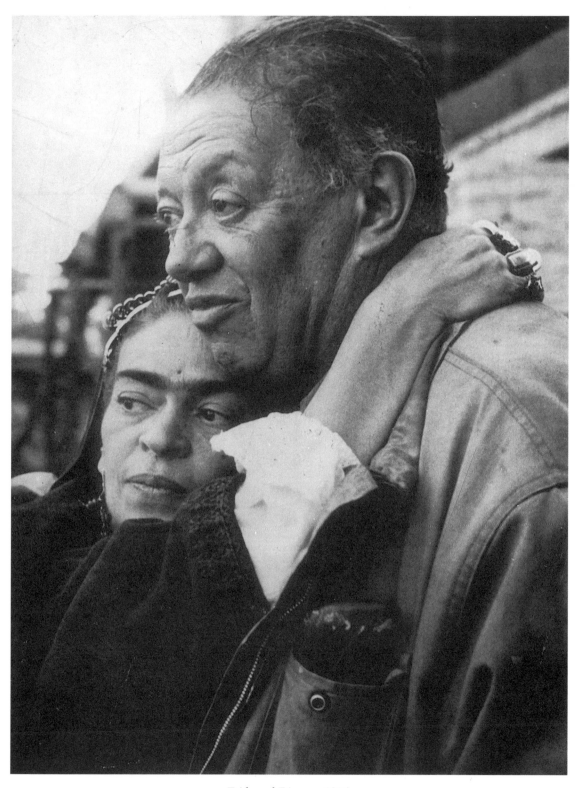

Frida and Diego, c. 1954

Chronology

1907 On July 6, Magdalena Carmen Frida Kahlo Calderón is born in Coyoacán, Mexico, the third of Matilde Calderón and Guillermo Kahlo's four daughters.

1913 Frida suffers an attack of poliomyelitis, permanently affecting the use of her right leg.

1922 Frida enters the National Preparatory School, where she meets Diego Rivera, who is painting his mural *Creation* at the school.

1925 On September 17, Frida is seriously injured in a streetcar accident. She begins to paint during her convalescence.

1926 Kahlo's earliest paintings include portraits of Alicia Galant, her sister Adriana, Miguel N. Lira, and a self-portrait dedicated to Alejandro Gómez Arias.

1929 On August 21, Kahlo marries Rivera. She is twenty-two years old; he is forty-three.

1930 On November 10 Frida arrives with Rivera in San Francisco.

1931 In San Francisco Kahlo meets Dr. Leo Eloesser, who becomes her life-long medical adviser.

After a brief trip to Mexico, in November Kahlo and Rivera travel to New York for his retrospective exhibition at the Museum of Modern Art.

1932 In Detroit for Diego's work on murals at the Detroit Institute of Arts, Frida is hospitalized because of severe hemorrhaging.

Kahlo's mother dies.

1933 Kahlo and Rivera return to New York. She paints *My Dress Hangs There (New York)* while Rivera paints murals at Rockefeller Center.

On December 20, Frida and Diego sail from New York for Mexico.

1934 Kahlo and Rivera live in adjoining studio-houses built for them by Juan O'Gorman in San Angel.

Rivera begins an affair with Cristina Kahlo, Frida's sister.

1935 Kahlo and Rivera separate. Kahlo temporarily takes an apartment in Mexico City, then in July travels to New York. When she returns, the couple reconciles.

1937 On January 9, Leon Trotsky and his wife, Natalia Sedova, arrive in Mexico and live at the Casa Azul.

1938 French Surrealist André Breton visits Mexico and meets Frida. American collector and film actor Edward G. Robinson purchases four works, her first significant sale.

From October 25 to November 14, Kahlo's first one-person exhibition is held at the Julian Levy Gallery in New York.

1939 Kahlo travels to Paris in January for *Mexique*, an exhibition organized by André Breton which features her paintings. The Louvre purchases her self-portrait *The Frame*.

Kahlo returns home in April, and in the fall she and Rivera begin divorce proceedings, which are finalized in November.

1940 In January *The Two Fridas* and *The Wounded Table* are exhibited in the *International Surrealism Exhibition* organized by the Gallery of Mexican Art.

Frida goes to San Francisco for further medical treatment from Dr. Eloesser. She shows her work in the *San Francisco Golden Gate International Exhibition*. *The Two Fridas* is shown in New York at the Museum of Modern Art's exhibition *Twenty Centuries of Mexican Art*.

On December 8 in San Francisco, Kahlo remarries Diego Rivera.

1941 Guillermo Kahlo dies.

Kahlo returns to the family home in Coyoacán to live.

1942 Rivera begins building Anahuacalli, his anthropological museum.

Kahlo's *Self-Portrait with Braid* is included in the exhibition *Twentieth-Century Portraits* at the Museum of Modern Art, New York.

1943 A Kahlo painting is exhibited in a group show, *A Century of the Portrait in Mexico (1830–1942)*, at the Benjamin Franklin Library, Mexico City. Her work is included in *Mexican Art Today* at the Philadelphia Museum of Art and is shown in Peggy Guggenheim's Art of This Century Gallery in New York.

Kahlo begins teaching at the Ministry of Public Education's School of Painting and Sculpture, La Esmeralda.

1946 Kahlo paints *The Wounded Deer* and *Tree of Hope, Stand Fast.* She goes to New York for surgery on her spine.

1947 *Self-Portrait as a Tehuana (Diego in My Thoughts)* is exhibited in *Forty-five Self-Portraits by Mexican Painters, from the XVIII to the XX Centuries* at the National Institute of Fine Arts.

1949 Kahlo writes the essay "Portrait of Diego" and paints *Diego and I* and *The Love Embrace of the Universe, the Earth (Mexico), Me, Diego, and Mr. Xólotl*, which is exhibited at the inaugural exhibition of the Salon de la Plástica Mexicana.

1950 Kahlo is hospitalized for nine months because of recurring spinal problems.

1951 Kahlo paints *Self-Portrait with Portrait of Dr. Juan Farill*, several still-lifes, and *Portrait of My Father.*

1953 From April 13 to 27, Kahlo's only individual exhibition in Mexico is held at the Galería de Arte Contemporáneo.

 In July her right leg is amputated below the knee because of gangrene.

1954 Frida is hospitalized in April and May. On July 2, convalescing from bronchial pneumonia, she takes part in a demonstration protesting U.S. intervention in Guatemala. On the night of July 13, she dies.

1957 On November 24, Diego Rivera dies in his San Angel studio. He is buried in the Rotunda of Famous Men in Mexico City, in contradiction to his expressed wish that he be cremated and his ashes commingled with those of Frida.

1958 On July 30, the Casa Azul is opened to the public as the Frida Kahlo Museum.

List of Illustrations

44

Portrait of Dr. Leo Eloesser (*Retrato del Dr. Leo Eloesser*), 1931
Oil on cardboard, 84 × 60 cm
School of Medicine, University of California, San Francisco
Photo: Nancy Breslow

45

Henry Ford Hospital (*Hospital Henry Ford*), 1932
Oil on metal, 30 × 38 cm
Collection of Dolores Olmedo, Mexico City

My Birth (*Mi nacimiento*), 1932
Oil on metal, 30.5 × 35 cm
Private collection, U.S.A.

48

Self-Portrait on the Border between Mexico and the United States (*Autorretrato en la frontera entre México y los Estados Unidos*), 1932
Oil on metal, 30 × 34 cm
Collection of Mrs. Manuel Reyero, New York

My Dress Hangs There (New York) (*Mi vestido cuelga ahí*), 1933
Oil and collage on Masonite, 46 × 50 cm
Hoover Gallery, Estate of Dr. Leo Eloesser

49

Portrait of Cristina, My Sister (*Retrato de Cristina, mi hermana*), 1928
Oil on wood, 99 × 82 cm
Sotheby's, September 21, 1988

51

A Few Small Nips (*Unos cuantos piquetitos*), 1935
Oil on metal, 29.5 × 39.5 cm
Collection of Dolores Olmedo, Mexico City

Sketch for *A Few Small Nips*, 1935
Pencil on paper
Museo Frida Kahlo, Mexico City

52

My Parrots and I (*Yo y mis pericos*), c. 1941
Oil on canvas, 80 × 61 cm
Private collection

53

Courtesy International Museum of Photography at George Eastman House, Nickolas Muray Collection

55

Self-Portrait Dedicated to Leon Trotsky (Between the Curtains) (*Autorretrato dedicado a Leon Trotsky*), 1937
Oil on board, 76.2 × 61 cm
The National Museum of Women in the Arts, gift of the Honorable Clare Boothe Luce

57

Portrait of Alberto Misrachi (*Retrato de Alberto Misrachi*), 1937
Oil on metal, 34 × 27 cm
Collection of Ana Misrachi, Mexico City

58

My Nurse and I (*Mi nana y yo*), 1937
Oil on metal, 30 × 35 cm
Collection of Dolores Olmedo, Mexico City

59

The Deceased Dimas (*El difuntito Dimas Rosas a los tres años de edad*), 1937
Oil on Masonite, 48 × 31.8 cm
Collection of Dolores Olmedo, Mexico City

60

The Suicide of Dorothy Hale (*El suicidio de Dorothy Hale*), 1938–39
Oil on panel, 60.4 × 48.6 cm
Phoenix Art Museum; gift of an anonymous donor

61

Fruits of the Earth (*Frutos de la tierra*), 1938
Oil on Masonite, 40 × 60 cm
Collection of Banco Nacional de Mexico, Mexico City

Flower of Life (*La flor de la vida*), 1938
Oil on metal, 18 × 10 cm
Private collection

Cactus Fruit (*Tunas*), 1937
Oil on metal, 20 × 24 cm
The Robert Holmes à Court Collection

63

Self-Portrait Dedicated to Dr. Eloesser (*Autorretrato dedicado al Dr. Eloesser*), 1940
Oil on Masonite, 59 × 40 cm
Private collection, U.S.A.

Self-Portrait (The Frame) (*Autorretrato con marco integrado y dos pájaros*), c. 1938
Oil on aluminum and glass, 29 × 22 cm
Musée National d'Art Moderne, Centre Georges Pompidou, Paris

65

The Two Fridas (*Las dos Fridas*), 1939
Oil on canvas, 173 × 173 cm
Museo de Arte Moderno, Mexico City

66

Self-Portrait with Cropped Hair (*Autorretrato con pelo cortado*), 1940
Oil on canvas, 40 × 28 cm
The Museum of Modern Art, New York; gift of Edgar Kaufmann, Jr.

67

The Earth Itself (Two Nudes in the Jungle) (*La tierra misma o Dos desnudos en la jungla*), 1939
Oil on metal, 25.1 × 30.2 cm
Courtesy Mary-Anne Martin/Fine Art, New York

68

Self-Portrait Dedicated to Sigmund Firestone (*Autorretrato dedicado a Sigmund Firestone*), 1940
Oil on Masonite, 60 × 42 cm
Collection of Violet Gershenson, New York

69

Self-Portrait with Monkey
(*Autorretrato con changuito*), 1938
Oil on Masonite, 40.6 × 30.5 cm
Albright-Knox Art Gallery, Buffalo,
New York; bequest of A. Conger
Goodyear, 1966
Photo: Biff Henrich

71

Photo: Nickolas Muray, courtesy
International Museum of Photography
at George Eastman House

72

Photo: © Juan Guzmán

73

Photo: Hermanos Mayo

75

Photo (top): © Juan Guzmán

Bottom: Courtesy Archivo General
de la Nación

76

Self-Portrait (Fulang Chang and I)
(*Autorretrato o Fulang Chang y yo*),
1937
Oil on composition board with
painted mirror frame, 40 × 28 cm,
(ptg. only), 57 × 43.8 (with frame)
The Museum of Modern Art, New
York; Mary Sklar Bequest

77

Self-Portrait with Thorn Necklace
and Hummingbird (*Autorretrato con
collar de espinas y colibrí*), 1940
Oil on Masonite, 60 × 40 cm
Harry Ransom Humanities
Research Art Collection, University
of Texas at Austin

78

Courtesy Archivo General de la
Nación

81

Self-Portrait (*Autorretrato*), 1941
Oil on canvas, 38 × 27 cm
Jacques and Natasha Gelman
Collection

Self-Portrait with Monkey and
Parrot (*Autorretrato con chango
y loro*), 1942
Oil on Masonite, 53 × 43 cm
Collection IBM Corporation,
Armonk, New York

Lower left: Frida, c. 1943
Courtesy Guillermo Monroy

82

Self-Portrait (*Autorretrato*), 1948
Oil on Masonite, 50 × 40 cm
Private collection

83

Self-Portrait as a Tehuana (Diego in
My Thoughts) (*Autorretrato como
Tehuana o Diego en mi pensamiento*),
1943
Oil on Masonite, 75 × 60 cm
Jacques and Natasha Gelman
Collection

84

Photo: © Emmy Lou Packard

85

Self-Portrait Dedicated to Marte R.
Gómez (*Autorretrato dedicado a Marte
R. Gómez*), 1946
Pencil on paper, 38 × 32 cm
Collection of Marte Gómez Leal,
Mexico City

87

Photo (top): Hermanos Mayo

88

Thinking of Death (*Pensando en la
muerte*), 1943
Oil on canvas, 45 × 37 cm
Private collection

90

Diego and I (*Diego y yo*), 1949
Oil on canvas, mounted on Masonite,
50 × 41 cm
Courtesy Mary-Anne Martin/Fine
Art, New York

92

The Love Embrace of the Universe,
the Earth (Mexico), Me, Diego, and
Mr. Xólotl (*El abrazo de amor de el
universo, la tierra [México] yo, Diego y el
señor Xólotl*), 1949
Oil on Masonite, 70 × 60 cm
Jacques and Natasha Gelman
Collection

94

Courtesy Emmy Lou Packard

98

Self-Portrait with Braid (*Autorretrato
con trenza*), 1941
Oil on canvas, 51 × 38 cm
Jacques and Natasha Gelman
Collection

101

Self-Portrait with Monkey
(*Autorretrato con mono*), 1940
Oil on Masonite, 55.2 × 49.5 cm
Private collection, U.S.A.

Bottom: Courtesy Museo Frida
Kahlo, Mexico City

103

Self-Portrait with Monkeys
(*Autorretrato con monos*), 1943
Oil on canvas, 81 × 63 cm
Jacques and Natasha Gelman
Collection

104

The Bride Frightened at Seeing Life
Opened (*La novia que se espanta de ver
la vida abierta*), 1943
Oil on canvas, 63 × 80 cm
Jacques and Natasha Gelman
Collection

Flower of Life (*La flor de la vida*),
1944
Oil on Masonite, 28 × 20 cm
Collection of Dolores Olmedo,
Mexico City

The Chick (*El pollito*), 1945
Oil on Masonite, 28 × 22 cm
Collection of Dolores Olmedo,
Mexico City

105

Sun and Life (El sol y la vida), 1947
Oil on Masonite, 38 × 48 cm
Collection of Manuel Perusquia,
Mexico City

Magnolias (Magnolias), 1945
Oil on Masonite, 41 × 57 cm
Private collection

106

Portrait of Mariana Morillo Safa
(Retrato de Mariana Morillo Safa),
1944
Oil on canvas, 36 × 26 cm
Private collection, Mexico

107

Portrait of Doña Rosita Morillo Safa
(Retrato de Doña Rosita Morillo Safa),
1944
Oil on canvas, mounted on Masonite,
75 × 60 cm
Collection of Dolores Olmedo,
Mexico City

108

Portrait of Lupita Morillo Safa
(Retrato de Lupita Morillo Safa), 1944
Oil on Masonite, 56.5 × 50 cm
Collection of Mr. and Mrs. Paul M.
Cook, Menlo Park, California
Photo: Fisher Photo

Portrait of Natasha Gelman (Retrato
de Natasha Gelman), 1943
Oil on canvas, 29 × 23 cm
Jacques and Natasha Gelman
Collection

109

Portrait of Marte R. Gómez (Retrato
de Marte R. Gómez), 1944
Oil on Masonite, 31 × 25 cm
Collection of Hilda Leal de Gómez,
Mexico City

111

Moses (Moisés), 1945
Oil on Masonite, 61 × 76 cm
Private collection, Houston, Texas

Four Inhabitants of Mexico City (Los
Cuatro habitantes de la ciudad de
México), 1938
Oil on canvas, 31 × 47 cm
Private collection

112

Roots (The Pedregal) (Raíces o El
pedregal), 1943
Oil on metal, 30 × 50 cm
Private collection, Houston, Texas

What the Water Gave Me (Lo que el
agua me ha dado), 1938
Oil on canvas, 90 × 71 cm
Courtesy Isidore Ducasse Fine
Arts Inc.

113

Self-Portrait with Unbound Hair
(Autorretrato con pelo suelto), 1947
Oil on Masonite, 60 × 44.1 cm
Private collection

115

Self-Portrait with Portrait of Dr.
Juan Farill (Autorretrato con el retrato
del Dr. Juan Farill), 1951
Oil on Masonite, 41 × 50 cm
Private collection

116

Tree of Hope, Stand Fast (Arbol de la
esperanza, mantente firme), 1946
Oil on Masonite, 54 × 40 cm
Courtesy Isidore Ducasse Fine
Arts Inc.

117

Frida wearing decorated plaster cast,
c. 1950–51
Photo: © Juan Guzmán

119

Photo (top and bottom): © Juan
Guzmán

120

The Wounded Deer (The Little
Deer) (El venado herido o La venadita),
1946
Oil on Masonite, 22.4 × 30 cm
Collection of Mrs. Carolyn Farb

121

The Broken Column (La columna
rota), 1944
Oil on Masonite, 42 × 33 cm
Collection of Dolores Olmedo,
Mexico City

125

Light (Fruit of Life) (Luz o Fruta de
la vida), c. 1954
Oil on Masonite, 45 × 62 cm
Collection of Jorge Espinosa Ulloa,
Mexico City

Long Live Life (Viva la vida), 1954
Oil on Masonite, 52 × 72 cm
Museo Frida Kahlo, Mexico City

126

Courtesy Museo Frida Kahlo,
Mexico City

127

Without Hope (Sin esperanza), 1945
Oil on canvas mounted on Masonite,
28 × 36 cm
Collection of Dolores Olmedo,
Mexico City

Bottom: Courtesy Galería La
Granja, Mexico City

128

Frida and Stalin (Frida y Stalin),
c. 1954
Oil on Masonite, 60 × 40 cm
Museo Frida Kahlo, Mexico City

129

Photo: Antonio Kahlo

Selected Bibliography

143

Chadwick, Whitney. *Women Artists and the Surrealist Movement*. Boston, London, and New York: Little, Brown and Company, 1985.

de Lappe, Pele. "The Intense Duality of Frida Kahlo." *The People's World*, November 1977: 10.

Garcia, Rupert. *Frida Kahlo: A Bibliography*. Chicano Studies Library Publication Series, no. 7. Berkeley: University of California, 1983.

Grimberg, Salomon. *Frida Kahlo*. Dallas: The Meadows Museum, Southern Methodist University, 1989.

Herrera, Hayden. *Frida: A Biography of Frida Kahlo*. New York: Harper and Row, 1983.

Kozloff, Joyce. "Frida Kahlo." *Women's Studies* 6 (1978): 43–59.

Mulvey, Laura, and Peter Wollen. *Frida Kahlo and Tina Modotti*. London: Whitechapel Art Gallery, 1982.

Orenstein, Gloria. "Frida Kahlo: Painting for Miracles." *Feminist Art Journal*, Fall 1973: 7–9.

Rivera, Diego, with Gladys March. *My Art, My Life: An Autobiography*. New York: Citadel, 1960.

Sullivan, Edward J. "Frida Kahlo in New York." *Arts Magazine* 57, no. 7 (March 1983): 90–92.

Wolfe, Bertram D. *The Fabulous Life of Diego Rivera*. New York: Stein and Day, 1963.